T0170797

OHIO SHORT HISTORIES OF AFRICA

This series of Ohio Short Histories of Africa is meant for those who are looking for a brief but lively introduction to a wide range of topics in South African history, politics, and biography, written by some of the leading experts in their fields.

Steve Biko
by Lindy Wilson
ISBN: 978-0-8214-2025-6
e-ISBN: 978-0-8214-4441-2

Spear of the Nation (Umkhonto weSizwe):
South Africa's Liberation Army, 1960s–1990s
by Janet Cherry
ISBN: 978-0-8214-2026-3
e-ISBN: 978-0-8214-4443-6

Epidemics:
The Story of South Africa's Five Most Lethal Human Diseases
by Howard Phillips
ISBN: 978-0-8214-2028-7
e-ISBN: 978-0-8214-4442-9

South Africa's Struggle for Human Rights
by Saul Dubow
ISBN: 978-0-8214-2027-0
e-ISBN: 978-0-8214-4440-5

San Rock Art
by J. D. Lewis-Williams
ISBN: 978-0-8214-2045-4
e-ISBN: 978-0-8214-4458-0

San Rock Art

J. D. Lewis-Williams

OHIO UNIVERSITY PRESS

ATHENS

Ohio University Press, Athens, Ohio 45701
www.ohioswallow.com
All rights reserved

First published by Jacana Media (Pty) Ltd in 2011
10 Orange Street
Sunnyside
Auckland Park 2092
South Africa
(+27 11) 628-3200
www.jacana.co.za

First published in North America in 2013 by Ohio University Press
Printed in the United States of America
Ohio University Press books are printed on acid-free paper ⊗ ™

20 19 18 17 16 15 14 13 5 4 3 2 1

ISBN: 978-0-8214-2045-4
e-ISBN: 978-0-8214-4458-0

Library of Congress Cataloging-in-Publication Data
Lewis-Williams, J. David.
 San rock art / J. D. Lewis-Williams.
 p. cm. — (Ohio short histories of Africa)
 "First published by Jacana Media (Pty) Ltd in 2011. First published in
North America in 2013 by Ohio University Press."—T.p. verso.
 Includes bibliographical references and index.
 ISBN 978-0-8214-2045-4 (pb : alk. paper) — ISBN
978-0-8214-4458-0 (electronic)
 1. Art, San—Africa, Southern. 2. Rock paintings—Africa, Southern.
3. Cave paintings—Africa, Southern. I. Title. II. Series: Ohio short
histories of Africa.
 DT1058.S36L482 2013
 709.01130968—dc23
 2013001099

Cover design by Joey Hi-Fi

Contents

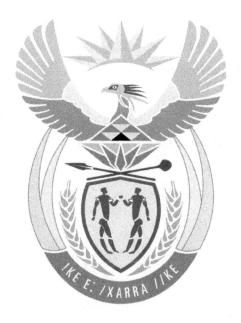

Fig. 1. The post-apartheid South African coat of arms.

1

An ancient tradition in today's South Africa

Many South Africans are unaware that the central image in their country's coat of arms derives from a San rock painting (Fig. 1). In 1994 South Africa moved out of the dark decades of apartheid and set out on a new democratic path. It was a time of renewal, and new symbols of unity had to be found. In due course, on 27 April 2000 President Thabo Mbeki unveiled a new national coat of arms. He and the government had decided that it would be appropriate to incorporate a San rock painting in the new design. They therefore approached the Rock Art Research Institute at the University of the Witwatersrand for suggestions, and then chose one image from the range that was submitted to them. As it now stands in the coat of arms, the selected rock painting seems to show two men facing one another with their arms raised in greeting. The President explained that the people who made the original rock painting 'were the very first inhabitants

of our land, the Khoisan people'.[*]

There is a story behind this image. In 1916 Dr Louis Peringuey, Director of the South African Museum in Cape Town, received a letter from Mr G.S.T. Mandy, a field assistant in the Provincial Roads Department. It informed him of the possibility of removing 'really magnificent' rock paintings from a remote rock shelter on the farm Linton in the Maclear district of what is now the Eastern Cape. Much correspondence followed in which Mandy described the tragic destruction of other valuable paintings and the growing threat to the panel in question. He told Peringuey that the cost of removal would be about £30 (a fair sum in those days) but that he considered 'the paintings will be worth any money if successfully removed'. Peringuey agreed. Both he and Mandy were determined to save the paintings, and work on their removal started in July 1917.

This proved a very difficult and time-consuming task because, as Mandy put it, the paintings 'had to be carved out of the solid rock and in most awkward positions'. A stonemason and a blacksmith were employed to undertake the work. At last, on 25 May 1918, Mandy sent a telegram to Peringuey announcing the successful removal of the very heavy 2 m x 0.75 m

[*] Linguists created the term 'Khoisan' by combining 'Khoi' or 'Khoe', formerly 'Hottentot', and 'San', formerly 'Bushman'; both peoples speak languages with clicks.

rock slab. Then they faced the task of getting the slab to Cape Town without damaging it. A track had to be built up on the slopes of the narrow valley in which the rock shelter is situated, and the stone was dragged to the top of the mountain on a sled. There it was transferred to an oxwagon and transported many kilometres over tortuous mountain roads to the railhead at Maclear. It finally arrived at the museum later that year. Delighted though they were, neither the Roads Department assistant nor the museum director could have had any idea of the far-reaching final outcome of their endeavours and of the role that the removed rock would play in the construction of a new national identity some 80 years later.

Today, next to nothing remains in the rather damp rock shelter from which the slab was removed. The paintings that Mandy had to leave behind have mostly weathered away. Moreover, to extract the panel by laboriously chiselling into the rock behind it, about 1.5 m of the rock face had to be destroyed on each side. Painted remnants remaining beyond the destroyed area suggest that the parts chiselled away were as densely painted with images as is the preserved portion. Although we may lament the loss of so many paintings that the removal of this one panel entailed, we can nevertheless be grateful that this key cornucopia of San imagery and belief is now safe from further

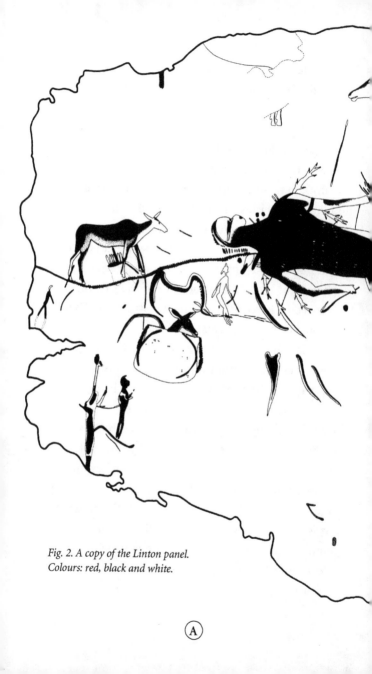

Fig. 2. A copy of the Linton panel.
Colours: red, black and white.

Ⓐ

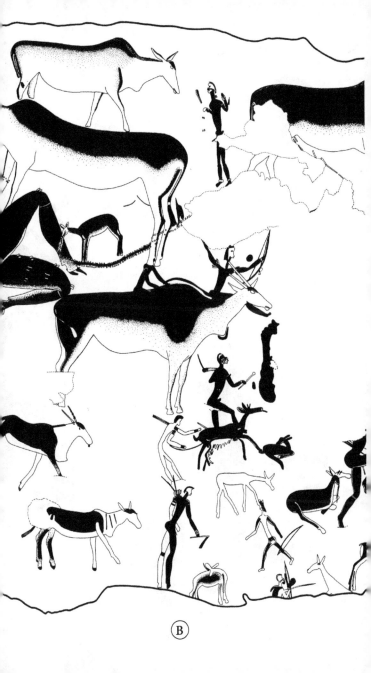

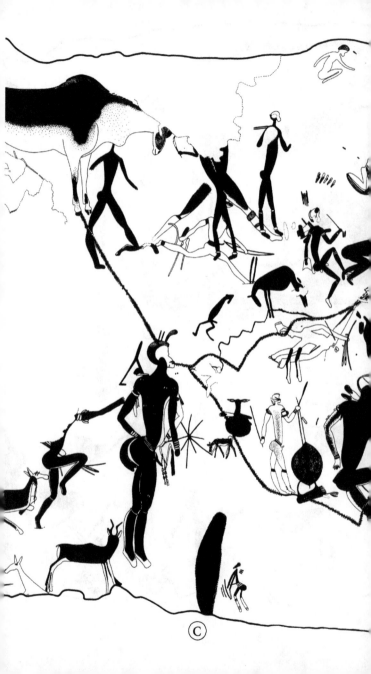

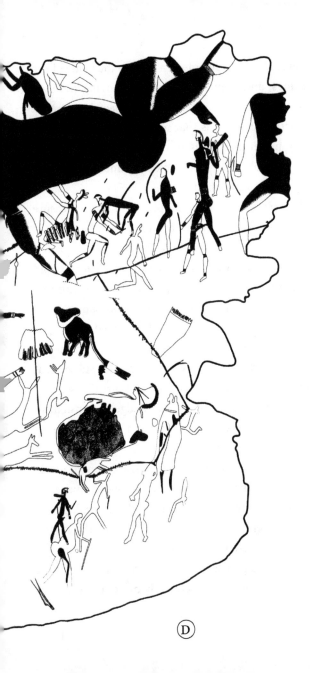

damage. Had Mandy not been alert to the value of the paintings, and then successful in removing the slab, the stunning images on it would have been lost forever. A sobering thought is that many of the hundreds of poorly preserved panels throughout southern Africa were probably once as complexly painted as what is today known as the Linton panel.

This piece of rock is undoubtedly a major treasure of the Iziko South African Museum (Fig. 2). But it is more than that. It is one of the greatest rock art panels in any museum anywhere in the world. That is a bold statement, but its excellent preservation, astonishing detail and the light its study throws on San rock art in general assure its primacy. The painted images, so baffling in their complexity and, in many instances, strangeness, lead us, as we shall see in subsequent chapters, into the heart of San rock art. This single piece of rock is a source of knowledge and insight to which researchers can return again and again as it slowly reveals its secrets.

By contrast, many rock art panels are comparatively simple. They may have only a few isolated images of animals. It is hard to say much about these simple panels beyond generalities. But some panels, like the Linton one, are crowded with complex and sometimes unique images. These panels hold more information than the simple ones and are consequently more rewarding for

those who would decode the 'messages' of San rock art, as we try to do in this pocket guide. This is not to say that panels with only a few apparently straightforward images are trite. On the contrary, much information is squeezed into simple images, information that is explicated in the complex panoramas of images. In Christian art, a single carved cross, for instance, implies a vast amount of information about God, the person of Christ, the Resurrection and so forth, whereas a painting of the Crucifixion with all the surrounding people and suggestions of divine intervention may make much of this information explicit.

The image selected for the coat of arms is a male human figure (Fig. 3). It holds an unusually large bow in one hand and a stick or spear in the other – it is not, as the coat of arms has it, a pair of facing men. Further, the original painted figure has red lines radiating from its nose and passing across its face; a leather bag filled with arrows lies at its feet. Most enigmatic is the curious narrow red line fringed with meticulous white dots on which the figure appears to stand. On either side of the standing man, the line leads on to other images of different kinds. (Fig. 2C).

The heraldry experts who oversaw the final design of the coat of arms made some significant changes. Principally, they duplicated and reversed the figure to give the impression of two men greeting one another.

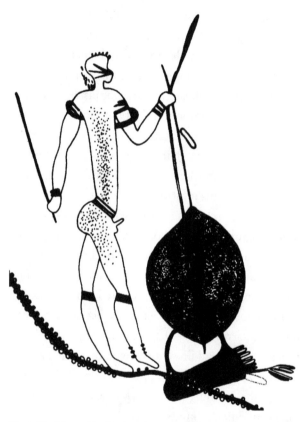

Fig. 3. *The human figure selected from the Linton panel for inclusion in the South African coat of arms.*

In addition, they omitted the facial lines, the arrow bag, the red line with white dots and, presumably in the interests of propriety, the figure's penis. President Mbeki summed up the significance of the resulting dual image in the new South Africa: 'It pays tribute to our land and our continent as the cradle of humanity, as the place where human life first began.'

The significance of two men greeting one another is also expressed in the new national motto which is part of the coat of arms. It is in the now-extinct |Xam San language: *!ke e: |xarra ||ke.* It means: 'people who are different come together', an apt sentiment for a divided nation attempting to move on from its violent, divisive past. (The symbols !, | and || denote the clicks that are characteristic of the Khoisan languages.) In fact, as it stands in the |Xam language without any particles, the motto can be read as indicative or imperative, that is, as a statement about what is happening in South Africa today, or as an injunction to people to come together.

The President explained the choice of the |Xam language: 'We have chosen an ancient language of our people. This language is now extinct as no one lives who speaks it as his or her mother-tongue. This emphasizes the tragedy of the millions of human beings who, through the ages, have perished and even ceased to exist as peoples, because of people's inhumanity to others.'[1]

With the coat of arms and motto in the forefront of South Africa's new, multi-ethnic identity, the San and their rock art have indeed 'arrived' – but only after a long and tragic history. The need for 'people who are different [to] come together' is still painfully acute.

Prejudice

When the early European settlers began to make their way into the interior of southern Africa, they encountered San hunter-gatherers and cattle-herding Khoekhoe, or 'Bushmen' and 'Hottentots', as they respectively named them. Today descendants of these peoples understandably find the old terms offensive. Soon, the explorers and settlers discovered that the San made rock art. With a few notable exceptions, they were unimpressed by the images that they came across on rock shelter walls. One writer described 'caves full of coloured drawings by the Bushmen' and denounced them as 'hideous', adding that 'each one is more ugly than its neighbour'. Two French missionaries, Thomas Arbousset and François Daumas, were somewhat more sympathetic and wished to counteract the colonial notion that the San worshipped the Devil, but they nevertheless described the images as nothing more than 'innocent playthings'.[2]

Prejudice, especially that based on race, dies hard.

In the 1920s S.P. Impey, a medical doctor who was much interested in the ways in which different 'races' supposedly populated the world, stated: 'I have known Bushmen all my life, and have been acquainted with paintings in our caves for over half a century, and knowing the Bushmen, I have always been unable to believe that people of such a low degraded type of humanity could have painted the pictures attributed to them.'[3] That a prominent South African publisher would, in the 1920s, place Impey's misinformed racist views before the public is indicative of just how enduring prejudices can be. Today such distasteful views are entirely discredited: far from being a 'low degraded type of humanity', the San were, and still are, no different from any other human beings. Yet one has to admit that there are still some, though fewer, people who tend to side with the early writers.

Contrary to the now fortunately minority view that the San were unable to make such delicate and complex paintings, this pocket guide shows that it is San beliefs and practices, and those alone, that 'fit' southern African rock art and unlock the meanings of images, such as those on the Linton panel. Despite the popular notion that, because all the painters are long since dead, we shall never know what the images mean, enough of the San's thought-world has been preserved to make understanding possible. We may not be able

to explain everything that we see painted in the rock shelters, but we are able to explain a great deal.

An embarrassment of riches

There are two fundamental types of San rock art: paintings and engravings. San rock paintings (sometimes known as pictographs) are concentrated in the many rock shelters of the mountainous rim of the central plateau of the subcontinent, though there are also paintings, generally rather cruder and far fewer, scattered across the interior. By contrast, rock engravings (also known as petroglyphs) are found in the interior on open rocks, sometimes along river beds and often on low hills or rises. The engravings were made by incising, pecking or scraping techniques that caused the generally lighter interior of the rock to show through the darker surface patina (Fig. 4). As the centuries passed, the patina often re-formed, and it is now difficult to see many of the engravings. Engravings were made by both San and Khoekhoe people. San engravings are generally finer than the pecked, and for the most part geometric, engravings that are today attributed to the Khoekhoe, but there is still some debate about which group made many of the engravings. In any event, the San and the Khoekhoe were not entirely separate, despite their different modes of making a living.

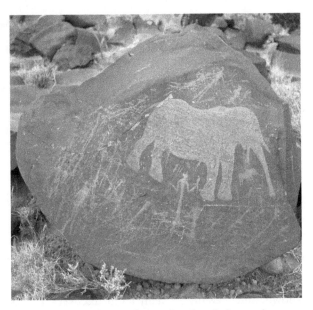

Fig. 4. A southern African rock engraving of an elephant and human figures.

In addition to San rock paintings, quite different paintings were made by Bantu-speaking agricultural people in the northern and eastern parts of southern Africa. These are easily distinguishable from San paintings: they were generally made with thick white paint that was applied with a finger, whereas the San, using brushes made from small reeds and animal hairs or feathers, achieved much finer lines. The Late Whites, as they are known, were generally made as part

of initiation rituals. They tend to be more repetitive than San rock art images. By their very nature, initiation rituals encourage conformity rather than personal insights and variations. There are also some rock engravings that are today believed to have been made by these agriculturalists: they portray stone-wall settlements and kraals.

This book focuses on images made by the San. Their paintings and engravings are scattered over the entire area of southern Africa and are far more numerous and more widely known than either Khoekhoe images or the Late White paintings. Indeed, San rock art presents researchers with an embarrassment of riches. It is estimated that some 15,000 San rock art sites are known, and possibly as many await discovery. By no means have all the known sites been studied. As more and more sites are studied in detail and, simultaneously, we are able to see more deeply into the complex beliefs and experiences with which San image-makers were concerned, the interpretations of San images that are given in this book will no doubt be expanded.

How old is San rock art?

Although new scientific techniques are today being developed, it is still hard to date individual rock art images. But we can give approximate dates for the overall San tradition. We know that the last images

were made in the south-eastern mountains of Lesotho, KwaZulu-Natal and the Eastern Cape towards the end of the nineteenth century or perhaps even in the first few years of the twentieth century. It was the makers of these images that the early colonists encountered. Some of these 'contact period' images depict horses and rifles, which were introduced into the region by white settlers in the nineteenth century. In the Western Cape and elsewhere, there are paintings of oxwagons and people in clearly Western clothing. Some of the nineteenth-century rock art of the Eastern Cape and southern KwaZulu-Natal was made by members of culturally mixed groups that formed as the traditional ways of life broke down. How those images should be interpreted is an issue that researchers are presently studying.

The other end of the time-scale is more difficult to pinpoint. Rock art images can be dated by two approaches: either by direct dating of the images themselves or by dating associated remains. Direct dating of rock paintings has until recently depended on the presence of radio-carbon in the paint, generally derived from charcoal, which was sometimes used to make black paint. Because radio-carbon breaks down at a fixed rate, researchers can calculate the age of the carbon and thus when the image was made. Recently, sophisticated use of this technique has

shown that some of the famous polychrome eland images in the KwaZulu-Natal Drakensberg may be nearly 3,000 years old – much older than hitherto suspected. The radio-carbon technique can, however, be employed only when the painters used charcoal as an ingredient of their paint. Images made entirely with, for instance, red ochre cannot be directly dated. The San mixed charcoal, ochre and other pigments, such as white kaolin, with water, plant juices and, as we shall later see, even animal blood to make paint that they could apply with a brush. Unfortunately, the medium lasted far less well than any of the pigments. More sophisticated dating techniques at present being developed will soon be available to researchers. These techniques extend further back in time than the radio-carbon determinations, which have until recently been the only ones available.

Indirect dating by association is possible in rare cases only. It is seldom that excavators of rock shelters find a painted stone or a fragment of painted rock that has fallen from the wall of a shelter and been buried in a stratum of the deposit. Nevertheless, a stratum containing a fragment of painted rock can occasionally be dated by carbon from a buried hearth or other source. Some of the most sensational successes of indirect dating have shown that the paintings on buried pieces of stone are two and more thousand

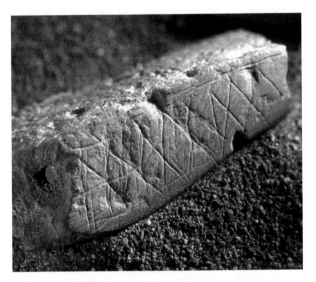

Fig. 5. Engraved ochre from the Blombos Cave.

years old. A number of these painted stones were discovered in rock shelters along the southern Cape coast. They are not pieces that fell from the wall of the shelter; rather, they are independent pieces of stone that people selected for painting. Significantly, a few of them had been placed over burials: image-making must have been ritually important at that time.

But by far the most sensational finds come from a time much more ancient. By indirect dating techniques, we know that people living in the Blombos Cave on the southern Cape coast engraved geometric patterns on small pieces of ochre just over 70,000

years before the present. The pattern is a series of crosses with a containing line and a line through the centre of the piece (Fig. 5). The astonishing date led some researchers to wonder if the engraved pieces had filtered down from a more recent stratum to the level in which they were found. That problem was resolved by the presence of a sterile layer of sand that collected in the shelter when the sea level fell and a wide expanse of sand and rock was exposed. The sterile layer which blew into the shelter from this exposed shelf sealed the older deposits: nothing moved down through it.

If we can call these pieces of engraved ochre 'art', then they are the oldest art known anywhere in the world. But the engraved patterns of crosses are not 'pictures' of recognisable things. Some researchers argue convincingly that the engraved crosses are symbols that stand for concepts we cannot now uncover. The engraved ochre, together with shell beads (some of which were stained with red ochre) found in the same deposit, suggests that Blombos is one of the earliest known sites where fully modern human beings lived. If we accept the Blombos ochre as art, we can safely say that the evidence so far available suggests that southern African rock art is the longest artistic tradition known anywhere in the world. Further, if these Blombos people can be seen as the forebears of the people we today know as San, they may well be

said, in President Mbeki's words, to be 'the very first inhabitants of our land'.

For the earliest known representational art, we must go to the Apollo 11 Cave in southern Namibia where painted pieces of stone have been found to have images of animals and a creature that appears to be a feline with human legs. The Apollo 11 pieces were dated to about 27,000 years before the present by means of radio-carbon found in the layer in which they were buried. Though reliable, they are therefore not direct dates. Interestingly, the Apollo 11 paintings are as much as 10,000 years older than the wall paintings in the famous Upper Palaeolithic cave Lascaux in France.

The study of this immensely long and complex tradition has passed through a number of phases. Far from being a purely detached, 'scientific' endeavour, the study of southern African rock art has, in some ways, paralleled the development of race relations in southern Africa. As the next chapter shows, what people say about San rock art is often (some would say inevitably) governed by the times in which they live.

2

Conflicting perspectives
and traditions

The initiation, efflorescence and demise of research
perspectives are always situated in specific social
circumstances. A history of such perspectives should
therefore try to identify the social, political and personal
forces that created conditions for their acceptance
and, in many instances, eventual rejection. There is a
catch here for the historian. The characterisation of
research contexts and the circumstances and values
to which individual historians of research point will
inevitably be in many ways framed by their own, often
unarticulated, values and aims. We tend to judge the
past by the present. All I can hope for is that the critical
periods in the history of southern African rock art
research that I identify in this chapter are, whatever
gloss I may place on them, empirically discernible in the
literature. People wrote about San rock art in different
ways at different times: there tended to be periods of

consensus separated by times of disagreement and sometimes quite bitter conflict.

To provide an understanding of this often turbulent history, I identify three periods of consensus separated by what I term 'nodes of conflict'. As I use the phrase, a node of conflict is created when trajectories of research, personal interests and socio-political trends come into conjunction in such a way that research, successfully or unsuccessfully, contests deeply held, unquestioned political or religious convictions of the public at large, not just the research community. Unlike some more abstruse scientific research, the nature of San rock art has always been part of the general public's conception of South Africa's past. The very phrase 'Bushman paintings' is known to virtually everyone in South Africa. Unfortunately, the prejudice evoked in many people by the word 'Bushman', even though they would not consider themselves racist, tends to obscure the depth and subtlety of the art.

The debates that characterised the nodes of conflict were conducted on at least two levels: personal and conceptual. In this pocket guide, I avoid comment on personal conflicts. Suffice it to say that, over the decades, rock art research has provided a public platform for numerous, sometimes forceful, personalities who have been reluctant to admit rivals. On the more interesting conceptual level, rock art research has been implicated

in a classic struggle to define and control a key, one could say 'archetypal', component of southern Africa's past – the San. More than just the painted images was at stake.

Colonial consensus (to 1874)

During the eighteenth and nineteenth centuries San hunter-gatherers were considered an impediment to colonial expansion. Because they did not till fields or tend herds of cattle or flocks of sheep, they were thought to have no land rights. They came to symbolise the irreducible, irredeemable essence of all southern Africa's indigenous people: they were seen as simple, untameable, childlike, idle and, crucially, incapable of adapting to more 'advanced' Western ways. As we saw in Chapter 1, San rock art was at that time regarded as primitive, incomprehensible, a sacrilegious affront to Christianity and, in some instances, indecent. All in all, the result was genocide, and military commandos were sometimes raised to exterminate them. Towards the end of the eighteenth century, the Swedish naturalist Anders Sparrman wrote: 'Does a colonist at any time get view of a Boshiesman, he takes fire immediately, and spirits up his horse and dogs in order to hunt him with more keenness and fury than he would a wolf or any other wild beast.'[4]

Those who escaped the colonists' bullets were

absorbed into other ethnic groups and, in the second half of the twentieth century, were eventually classified under the apartheid system (along with others) as 'coloured'. Although some Kalahari Desert groups in Namibia and Botswana have maintained a measure of independence to the north, no traditionally functioning southern San communities remained by the end of the nineteenth century.

The first node of conflict (1874)

In 1874 the first node of conflict was jointly generated by Joseph Millerd Orpen (1828–1923) and Wilhelm Heinrich Immanuel Bleek (1827–1875) (Fig. 6). Orpen, a colonial administrator, and Bleek, a German philologist who was studying the Khoisan languages, both took time to listen to San people talking about rock paintings or, in Bleek's case, copies of rock paintings that had been made by Orpen and George William Stow. Stow was a geologist who worked in what are now the eastern Free State and the Eastern Cape. After reading Orpen's article on San mythology and contemplating the copies of paintings that Orpen had made in the Maloti Mountains of southern Lesotho, Bleek challenged the current negative assessment in a short piece that the editor of the *Cape Monthly Magazine* asked him to write. It was published at the end of Orpen's article. In it, Bleek used Orpen's

word 'mythology' to cover general beliefs and, as we shall see, rituals. 'The fact of Bushman paintings, illustrating Bushman mythology, has first been publicly demonstrated by this paper of Mr. Orpen's; and to me, at all events, it was previously quite unknown, although I had hoped that such paintings might be found. This fact can hardly be valued sufficiently. It gives at once to Bushman art a higher character, and teaches us to look upon its products not as the mere daubing of figures for idle pastime, but as an attempt, however imperfect, at a truly artistic conception of the ideas which most deeply moved the Bushman mind, and filled it with religious feelings.'[5]

In its time, this was a remarkable and sensational statement, and it has remained much quoted. Bleek fully realised that he was initiating a challenge to received views. Lest there be any doubt, he went on to say that the publication of further high-quality copies of paintings would 'effect a radical change in the ideas generally entertained with regard to the Bushmen and their mental condition'. In this forthright way he challenged the views of his contemporaries on at least three important issues.

First, long before the phrase became fashionable with archaeologists, Bleek urged the necessity of an 'insider's view' of San rock art. At that time (and even today) people simply looked at the art and 'read' it in

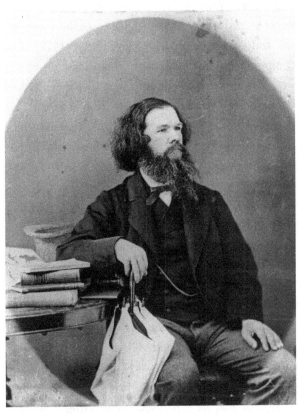

Fig. 6. Wilhelm Heinrich Immanuel Bleek (1827–1875).
A version of Orpen's copy of rock paintings is propped up at his elbow.

terms of their own Western beliefs and conventions. By contrast, Bleek compared the information that Orpen had secured from a young San man with the much larger record of San beliefs that he and his sister-in-law and co-researcher Lucy Lloyd (1834–1914) were compiling. He concluded that certain religious beliefs were not only widespread but were also expressed in the paintings. He realised that an 'insider's view' was the only key to the art. He wrote: 'A collection of faithful copies of Bushman paintings is, therefore, only second in importance to a collection of their folklore in their own language. Both collections will serve to illustrate each other, and contribute jointly towards showing us in its true light the curious mental development of a most remarkable race.'[6] Although we may see here some phraseology that is typical of Victorian thinking, Bleek is clearly saying that the ethnography and the rock art are two sides of a single coin.

Secondly, Bleek fully realised that the rich mythology that he and Orpen were compiling contradicted the contemporary colonial view of the San and their art. The words that Bleek chose seem to suggest that he was directly answering Arbousset and Daumas, who, as we saw in the previous chapter, declared that San paintings were 'innocent playthings'. Bleek strongly rejected the notion that the art was, as he put it, 'the mere daubing of figures for idle pastime'.

On the contrary, he knew that some colonial writers had denied that the San had any form of religion, and his use of the phrase 'religious feelings' must have been startling at the time.

Thirdly, and most importantly, Bleek realised that this new conception of the art challenged his contemporaries' low estimations of the status of the San as human beings. The publication of further copies of San rock paintings would, he wrote, 'effect a radical change in the ideas generally entertained with regard to the Bushmen'.[7] He fully recognised that rock art research was, in today's parlance, a concept-forming practice that went beyond the images themselves to ideas about the people who made them.

Wilhelm Bleek was thus well ahead of his time. Why did he risk confronting his contemporaries? To answer that question we need to look at the intellectual and social tradition from which he came. His father, Professor Friedrich Bleek, was a liberal theologian who was prepared to question the Bible. It was through another liberal theologian and friend of the Bleek family, Bishop John William Colenso, that Wilhelm was invited to the British Colony of Natal to compile a Zulu grammar. Colenso had just been appointed Bishop of Natal. Some years later, Colenso was arraigned on a number of charges of heresy. Some of these were posited on his belief that God was in all

people, even the unconverted 'heathen' whom he was supposed to convert. In the event, he refused to go to Cape Town to face his accusers because he did not recognise the authority of the Bishop of Cape Town. His friend Wilhelm Bleek, not himself a believer, consented to conduct his defence in the ecclesiastical court – unsuccessfully, as it turned out, and Colenso was excommunicated.

At the time when Bleek was conducting his San researches, there was thus a major struggle being waged between colonial views, aided and abetted by the British government, and a more liberal tradition. Within the Anglican Church this power struggle led to the rift between Colenso and the Bishop of Cape Town, and eventually to a schism in the Anglican Church which endures to this day, though on different theological grounds.

The publication of Bleek's and Orpen's confrontational work in 1874 seemed to set the stage for socially sensitive rock art research. Unfortunately, it was not to be. Orpen was increasingly drawn into colonial administration and what was known as 'native affairs'. Even more unfortunately, Bleek died in August 1875, and his hopes for 'a radical change in the ideas generally entertained with regard to the Bushmen' were not fulfilled. Bleek knew what changes could have resulted from the rich insights that he and Orpen had

begun to uncover. If he had lived longer, would he have been surprised at the failure that lay ahead? Probably not. His friend Colenso's excommunication must have shown him just how entrenched conservative colonial opinions and attitudes were. They were too deeply ingrained to admit change.

Bleek's and Orpen's work produced invaluable records of San beliefs, myths and rituals, but those records lay dormant until their significance was realised only a century later. The first node of conflict thus did not immediately affect the course of rock art research. During the decades that followed it, researchers showed little interest in seeking an 'insider's view' of San rock art.

Decades of consensus (1875–1967)

For many decades after the death of Wilhelm Bleek, writers reverted to explanations that denied the San symbolic or religious thought. When Bleek died, his work was continued by Lucy Lloyd, who had already contributed so much to what is now known as the Bleek and Lloyd Collection. After her death in 1914, the family mantle fell on the shoulders of Wilhelm's daughter Dorothea Bleek (1873–1948). Strangely, and despite the immense amount of valuable work that she did, she became partly responsible for a reversion to the old ways of seeing the San. In 1923 she wrote: 'The

Bushman ... remains all his life a child, averse to work, fond of play, of painting, singing, dancing, dressing up and acting, above all things fond of hearing and telling stories.'[8] Dorothea Bleek's highly respected reputation as 'the world's greatest expert on the Bushmen'[9] gave the stereotype of the San as being no more than children the status of orthodoxy. We can only guess what Bleek's reaction would have been to his daughter's shallow characterisation of the San.

In 1928 the Cambridge archaeologist Miles Burkitt visited South Africa and wrote an influential book in which he said that rock paintings should be studied by the same methods as were then used to study stone tools: stratigraphy and typology. Accordingly, researchers set about producing stylistic sequences based on analyses of the superimposition of images one upon another, a feature of San rock art. But as time went by, researchers seldom, if ever, found the suggested stylistic sequences very convincing or, for that matter, illuminating. All too often, a sequence established in one shelter was contradicted by the paintings in another shelter.

More significantly, and in direct contrast to the future of San rock art research that Bleek and Orpen had envisaged, Burkitt wrote: 'As regards the motives which prompted the execution of the paintings and engravings, little can be said.' As a result, the meaning, or meanings, of the art were for many years considered

unknowable. For Burkitt, the Western concern with technology (stone tools) was more important. This emphasis maximised both the technological and, by extension, the 'mental' distance between Africa's past and its industrial colonial present. 'They' were primitive; 'we' are sophisticated.

This 'distance' between 'us' and 'them' is evident in the work of one of the most influential figures of this period, Alex Willcox. Echoing Dorothea Bleek, he wrote: 'Palaeolithic man and his modern representative the Bushman remained, in their capacity for abstract thinking, always young children'.[10] Unlike some of his contemporaries, Willcox resolutely rejected fanciful explanations and remained a sober researcher who tried always to be 'scientific'. But when he went beyond the objective, 'scientific' study of the art, colonial prejudices began to surface.

Nevertheless, the perspective that saw the San as 'children' seemed to clash with the sophistication of at least some of the images. Could people who were mentally no more than children produce such beautiful images of eland and other animals? In the 1870s Wilhelm Bleek expressed the hope that photographs would correct the public's misapprehension: 'Where photography is available, its help would be very desirable, as the general public is skeptical, and not infrequently believes that the drawings are too good

not to have been vastly improved in copying, thereby doing scant justice to Bushman art.'[11]

As a result of the colonial attitude, some researchers did not take the route that Bleek advocated. Instead, they postulated the arrival of people of Mediterranean origin in southern Africa. These researchers argued that it was foreigners, not the San, who had generated the art. Thus it was that the famous French researcher Abbé Henri Breuil believed that he could identify a painting of a 'White Lady' in the Brandberg in Namibia. This 'discovery' was enthusiastically received by many people. The Prime Minister of South Africa, General J.C. Smuts, wrote to Breuil: 'You have upset all my history … When you publish these paintings, you will set the world on fire and nobody will believe you.'[12] Today we know that 'The White Lady of the Brandberg', famous though 'she' is, is neither white nor a lady: the image is of a male figure carrying a bow. The Abbé somehow missed seeing its penis.

During this period of consensus, San rock art became known to the public by means of profusely illustrated books, often in themselves very beautiful. Bleek's wish that more copies would become available seemed to be fulfilled – but there was a problem. Although some of these books challenged the racist stereotypes of the time, most simply reflected, entrenched and disseminated colonial estimations of

the San as childlike people who made naive pictures of their daily life. Indeed, the art as a record of daily life (with a small admixture of 'mythology') was the generally accepted concept of the art. Because rock art research deals with inanimate, apparently ancient images painted or engraved on rock surfaces, it has sometimes given the impression that it is removed from direct comment on the makers of the art, the San themselves. The full impact of the concept-forming role of these books has thus been concealed.

Despite these problems, it must be said that much useful empirical work was done during these decades of consensus. The names of such indefatigable researchers as Harald Pager, Alex Willcox, Bert Woodhouse, Neil Lee, the Focks (husband and wife), the Rudners (also a husband and wife team), Lucas Smits, the artist Walter Battiss, and Townley Johnson deserve honourable mention. Researchers still consult their picture-filled books. But during this period Bleek's sense of 'religious feelings' was ignored and the art was primarily seen as a secular record of daily activities.

The second node of conflict (1967–1972)

In the watershed year of 1967, three academic papers introduced a new quantitative technique for rock art research. Researchers hoped that by adopting this seemingly objective approach, rock art research would

fall into line with 'mainstream' archaeology, which was at that time emphasising scientific method. In one of these papers, Patricia Vinnicombe set out the numerical system she was using to compile quantitative inventories of the southern Drakensberg rock art. In another she suggested that the high percentage of eland depictions indicated 'the important part this animal played in both the economy and religious beliefs of the painters'.[13] In the third paper Tim Maggs summarised his independent quantitative work in the Cederberg. He too concluded that the large number of eland paintings suggested 'some particular importance of a religious nature'.[14] It seemed that rock art research was poised on the threshold of a great advance, but few researchers were prepared to undertake the exhausting and time-consuming work that the numerical recording and analysis of, literally, thousands of paintings demanded.

Today there is disagreement about the value of the quantitative rock art work that was undertaken at that time. The main problem was in fact evident right from the start, though it tended to be overlooked. As long ago as 1908, Alice Werner had commented on the prominence of the eland in San rock art and suggested that it was 'in some sense also a sacred animal'.[15] Then in 1958 Walter Battiss had suggested that 'the painters worshipped the eland and that its representation had a

very special religious significance'.[16] Werner and Battiss came to this conclusion without any quantitative work: the prominence of the eland was long obvious simply upon inspection of the art. But the main point here concerns the logic implied by quantification. Despite what some researchers hoped would be the case, one cannot move from numbers to meaning, as I found in my own quantitative work in the Drakensberg. It could, for example, be argued that the wildebeest, not the eland, was the most sacred animal for the San because so few painters dared to depict it, while anyone could paint eland. The argument can thus be turned on its head. If we wish to move from numbers and percentages to a concept of the eland as 'a sacred animal', something extra is needed to take us beyond numbers.

It was the silence of numbers that led to greater emphasis on San ethnography – the records compiled by Bleek and Orpen and the more recent post-Second World War studies of the Kalahari San groups. Immediately, researchers divided into two camps. Those who worked with the ethnography concluded that the art was a subtle expression of religious concepts and experiences, the ones which in Bleek's phrase 'most deeply moved the Bushman mind'. Those who did not take the ethnographic route remained wedded to the notion that the art was a simple record of a simple way

of life painted by simple people. Few of them actually read the entire Bleek and Lloyd Collection. Thus it was that the debate over the usefulness of quantification led, not without considerable conflict, to the reliance on ethnography, which most researchers today take for granted.

Conflict within consensus (1967 to the present)

The turn to San ethnography opened Pandora's box. It seemed clear to most researchers that San ethnography held the key to understanding the art. But, at the same time, researchers could not agree on what parts of the enthnography are relevant to the art. How exactly does one turn the ethnographic key?

Some writers emphasised the social context of the art. Borrowing from the social anthropology of the day, they took a functionalist approach; that is, they thought that the art served (functioned) to hold San society together. Others, also borrowing from social anthropology, took a structuralist approach. They followed the French savant Claude Lévi-Strauss and argued that the art dealt with binary oppositions and their resolution. For instance, Vinnicombe wrote: 'The eland was the medium through which the oppositions of life and death, of destruction and preservation, were resolved.' I also followed this path: 'The graphic compositions make, as do the myths, statements and

44

resolve oppositions on various levels . . .: sociological, techno-economic, metaphysical and, possibly, geographical.'[17]

Statements like these are, in essence, functionalist: they suggest that the art in some way worked towards the unity of San society by coping with contradictions. Today we see teleological problems here. One cannot explain a social institution (like rock painting) by the end it is imagined to serve. Social solidarity can be blandly suggested as the *raison d'être* of a whole range of institutions. More pertinent questions are: Did the San paint with the conscious intention of maintaining the solidarity of their society by means of their images? If not, what did they have in mind?

With the demise of structuralism as a philosophical position, writers took other approaches. Some, especially those of a feminist persuasion, saw the art as dealing principally with gender relations and the construction of male and female statuses. All arts that depict human beings can probably be said to impact on gender relations, but there is no evidence to support the view that the San intentionally made images in order to comment on gender relations. Why then did they make images? The following chapters show that both the painted and the ethnographic evidence point in a different direction altogether.

Another social explanation drew on Marxist

concepts. It suggested that San shamans worked within the social relations of production that produced the necessities of life to control resources by making rain and guiding hunters to antelope. Still others, fascinated by the myths that Orpen and the Bleek family recorded, saw the art as depicting a mythological realm. The 'depiction' of mythology, a view still fairly widely held, raises interesting questions. Does it take us back to the old idea of San rock art as a depiction of daily life, the recounting of myths being a part of daily life? This view, like the others that I have mentioned, side-steps the issue of what exactly a painted image was for the San. Was it merely a 'picture' such as we may find in a newspaper, be it of an animal seen in the veld or a personage in a myth? In fact, very few mythological characters (largely animals that behave as if they were people) appear in the paintings, and, when they do, they are not in contexts that point to myths: the personnel of mythology and art are plainly and markedly different. If the images were not simple 'pictures', what were they? Were they more like the icons around which religious rituals are built in the Orthodox Christian Churches? We return to these questions in later chapters.

We need not now follow up all the approaches that were advocated during this period, fascinating though many of them are. In some ways, it could be said that

each approach added something to our increasingly complex understanding of San rock art. Instead, I emphasise the nature of the consensus that underlies all of them: if we want to understand the art, we must study San ethnography, that is, authentic records of San religion, rituals, mythology and the kinship structures in which they functioned. But that is not all.

There are two guiding principles that we must keep in the forefront of our minds. If any consensus is to be reached on what San rock art meant to the people who made it, it will have to be founded on these two principles.

First, we must give as much attention to the images as to the ethnography. All too often, what appear to be exciting new approaches and insights, such as some of those I have mentioned, are founded on the ethnography combined with a theoretical position popular at the time, but pay little attention to the details of the imagery. They consequently carry no weight. This is the fate of the armchair researcher who has not studied literally hundreds of painted rock shelters in the field. Illustrated books are no substitute for hands-on work.

Secondly, we must evaluate the 'fit' between the themes in the ethnography to which we are attending and the images. The art does not depict *everything* that the San did; for instance, quantitative research

showed that hunts were not, contrary to popular belief, commonly painted. *We must be able to point to specific, repeated features of the paintings that dovetail with the ethnography. The more parallels that we find between a theme in the ethnography and the art itself, the greater will be our confidence that we are on the right track.*

Bearing these principles in mind, we can return to the rock painting that stands in the centre of the South African coat of arms. If we are to follow these principles, we need to examine the features of the image that the heraldry experts chose to omit.

3

Keys to the past

As I have pointed out, the image that appears in the centre of South Africa's coat of arms (Fig. 1) is merely a small part of the large, crowded Linton panel (Fig. 2). At first glance, we may think that these apparently jumbled images are all independent of one another. But that idea must be abandoned when we notice that there is a bifurcating thin red line fringed with small white dots that runs through the whole panel: it joins images that are far apart and others that are closer to one another yet seem to be in no 'scenic' relationship. For instance, the 'hunts' that are sometimes thought to be a central feature of San rock art are entirely absent from the panel; although a few figures hold bows, none is shown shooting at an animal.

Then, too, the line itself is clearly not 'realistic': it appears to enter and leave human figures as well as animals. Most of the antelope look like real antelope and are beautifully delineated. On the other hand,

some of the images are, like the line with dots itself, clearly not 'realistic'. There is, for instance, a snake with an antelope head that seems to bleed from its nose, and a supine human figure that has antelope hoofs (Fig 2A). All in all, the whole panorama leads us away from any real world in which we can identify things we know and into a realm that is 'rich and strange'.

Faced with this sweep of enigmas, we feel forced to say that we shall never understand such flights of the human mind. All we can do is gaze and marvel at the images and try to guess at what they could possibly have meant to the San who painted them and who looked at them daily as they lived in the rock shelters. Is anyone's guess as good as anyone else's? After all, the people who painted the images died a long time ago and we cannot question them. Still today, there are people who cling to this 'we-shall-never-know' position. Sometimes, mystery is more attractive than knowledge.

Fortunately, the paintings are only one part of what we know about the San. As I noted at the end of the previous chapter, we must maintain a balance between the images themselves and the records of San beliefs and life that are available to us. But the record of San beliefs, the ethnography, is itself made up of separate records that were compiled at different times and in different places. The ethnography is not just a key to the mystery of the paintings: it is a bunch of keys.

Nineteenth-century records

First, there are the writings of early European travellers and missionaries who struck out into the unknown interior of southern Africa. By and large, the information contained in their books is slight and prejudiced, though there are exceptions, such as the missionaries Thomas Arbousset and François Daumas, who garnered much information in the Maloti Mountains and to whom I refer in subsequent chapters. But if we had to rely entirely on colonial explorers, we should know very little about the San who made the art – that is, beyond their nomadic life style and their deadly poisoned arrows which so fascinated and terrified the early explorers. Fortunately, there are two other nineteenth-century sources: they have become foundational to San rock art research.

Both these nineteenth-century records were made at the time when the San were painting their last images in the rock shelters. The San people whose words were recorded, though not themselves painters or engravers, knew about the art and recognised the paintings, copies of which some of them were shown, as the work of their own people: they held the same belief system as the artists. I say 'whose words were recorded' because that is exactly what happened in one remarkable case.

Being a philologist who had studied ancient

languages, Wilhelm Bleek, whom I mentioned in the previous chapter, was able to record in a phonetic script the exact words and sentences that the San used. This means that we can today utter the words of a language that has been extinct for over a century. Bleek and his sister-in-law Lucy Lloyd took down approximately 12,000 pages of texts – and that astonishing number refers to only the right-hand pages of their notebooks, the left-hand pages, which were reserved for notes on the main texts, being labelled 'reverso'. Lloyd continued to work with the collection and saw to the publication of *Specimens of Bushman Folklore* in 1911, three years before her death. Today Bleek's and Lloyd's notebooks are housed in the Jagger Library, University of Cape Town; the entire collection has been electronically scanned and is available on disc.

From 1870 to his death in 1875, Bleek concentrated largely on working out |Xam grammar, while Lloyd took down the narratives, translated them word by word into English and annotated them. Because Bleek and Lloyd tried to be as accurate as they could when they were transcribing the sounds of the |Xam language, there are small variations in the phonetic script of certain words. I have standardised the phonetic spelling of all the words that I discuss according to the *Bushman Dictionary*, which Dorothea Bleek compiled but which J.A. Engelbrecht prepared for publication.

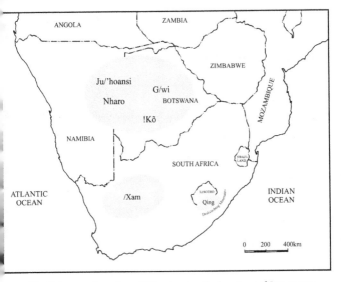

Fig. 7. A map of southern Africa showing the locations of San groups.

|Xam is the language celebrated in the South African national motto.

The southern San people from whom all this material was recorded lived in the semi-arid central parts of what is now South Africa (Fig. 7). Initially, they were brought to Cape Town as convicts, but the Governor allowed some to leave the prison and to live with the Bleek family in their suburban home. Others joined the Bleek family of their own volition. Bleek and Lloyd were never able to see rock paintings in their original settings. Instead, they had to rely on copies, some of which were crude and highly selective, but

53

others, especially those made by George William Stow, were much more useful. They showed these copies to the San and asked for comments.

The |Xam San lived in small bands, apparently of about 25 members in number. Membership of the bands was fluid and people intermarried and moved from band to band. They camped near but not at a waterhole because they did not wish to frighten away the animals that came to drink there. They lived entirely by hunting animals and gathering plant foods.

One long text that Lucy Lloyd recorded over a five-month period in 1872 is a poignant record that gives us some idea of what life was like for the |Xam. The narrative tells how a man was fatally wounded by a poisoned arrow while he and his friends were out hunting springbok. He and some others had crouched behind bushes, waiting for their fellows to drive a herd of springbok in their direction. When the running herd approached, the antelopes' hoofs raised a great cloud of dust. Hoping to hit one of the springbok, a man shot a poisoned arrow into the dust but accidentally wounded one of his fellow hunters, whom he could not see for the dust. No attempt was made to save the wounded man, because everyone knew that there was no antidote for the poison. They carried him back to their camp. Knowing that he was dying, the man spoke to his wife and expressed his concern for his children: 'I

who was bringing them meat die … I shall not see you again; for the time to talk is over. I am still, I shall not speak in the darkness.'[18]

After the man had died and was buried, the widow undertook a two-day trek across the semi-arid plains to rejoin her father's band. She took her children with her, and they filled ostrich eggshells with water to sustain themselves on the journey. At the distant camp they found her father and some of her brothers. The old man had been unable to follow the rest of his band when they left for another waterhole because his knees were troubling him. His sons remained to look after him. The narrator of the story pointed out that these men would teach the woman's children, their nephews, how to make arrows and how to hunt. This moving story gives us a glimpse of the life and sorrows of living in the harsh environment of the central parts of South Africa.

The second most important nineteenth-century key to the art is the article that Joseph Orpen published in the *Cape Monthly Magazine* in 1874 and on which the editor invited Wilhelm Bleek to comment. Orpen had been sent with a party of soldiers into the Maloti Mountains of southern Lesotho to apprehend Langalibalele, a Hlubi chief who had fled the Colony of Natal. Orpen was unsuccessful, but the expedition paid handsome dividends in another way. He engaged

a young San man named Qing to guide him through the maze of vast valleys (the Q in the man's name represents the click for which Bleek and Lloyd used an exclamation mark). On the way, Qing took him to painted rock shelters and there explained the images. Unlike Bleek, Orpen was not a philologist and therefore was unable to take down the actual words that Qing used. Instead, he had to rely on interpreters.

Orpen's article has, as later chapters of this book repeatedly show, become one of the most important sources of information on San rock art. Despite the limitations of the circumstances and the way in which Orpen was obliged to record Qing's remarks, we must remember that it was a San man who took Orpen to see paintings and who offered comments on those paintings – a unique occurrence.

Here I must emphasise a few important points. They have led some researchers to undervalue the remarks that Qing gave Orpen and even what Bleek and Lloyd learned from their |Xam informants when they asked them to respond to copies of rock paintings. One of these points is that indigenous informants are not social anthropologists: they do not give explanations couched in Western terms and concepts. They speak in their own idiom. This means that we have to interpret what they say – often no easy task. Indeed, the translation of one culture into another is a problem

that has long exercised the minds of anthropologists.

Many of the remarks on rock paintings that Orpen and the Bleek family obtained are laconic. A comparison shows why this is so. A Christian asked to comment on a painting of the Crucifixion may say that it is a picture of Jesus nailed to a cross. He or she may consider that brief identification to be an adequate explanation and not go into all the theology concerning the person of Jesus, the Trinity, sin, sacrifice and so forth. All that background could be taken for granted. Similarly, a San person may simply identify what he or she sees in a painting and not give the complex background necessary for us to understand its full significance. Some San comments may seem trivial simply for this reason. Researchers have to take their brief comments and situate them in the whole milieu of San thought and religious belief.

Then, too, we must remember that the informants' statements were given in response to questions that were put to them. For the most part, we do not have a record of those questions. The San texts that have come down to us therefore tacitly reflect the interests of the researchers who compiled them, not necessarily those of the San themselves.

One way out of these dilemmas is open in the Bleek and Lloyd Collection but not in Orpen's *Cape Monthly Magazine* article. The most reliable way that we can

achieve some understanding of what the Bleek family's informants said about the copies of rock paintings is, where possible, to find the actual key |Xam words that they used. Then we need to track those words through the entire collection so that we can understand their connotations. To get at the appropriate nuances of a |Xam word we usually have to translate it, at least initially, by a sentence or phrase. Thereafter, researchers hope that their readers will allow for the necessary San connotations when they come across the English word on which they finally settled. To avoid potential misunderstandings it is, however, sometimes best to retain the |Xam words in italics. Overall, we can say that the amount of attention that rock art writers pay to actual |Xam words is an indication of the reliability of what they have to say about the art.

Twentieth-century ethnography

When Bleek and Lloyd were working with |Xam people from what is now central South Africa, reports were filtering through of San groups who lived far to the north in the Kalahari Desert and who spoke different languages. At one point, some young boys from the north stayed with the Bleek family, and it was thus possible for Bleek and Lloyd to study the differences between the boys' language and the |Xam language with which they were already familiar. For the most

part, the two languages were mutually unintelligible. The boys came from a linguistic group that was known as the !Kung but today is known as the Ju|'hoansi (Fig. 7). They still live in the north of Namibia and Botswana. These Kalahari San were not driven into the inhospitable desert by 'stronger races', as is popularly supposed; rather, they have successfully lived there for thousands of years.

As it turned out in the second half of the twentieth century, the Ju|'hoansi became one of the best-known communities of hunter-gatherers in the world – a textbook case for anthropology students. In 1951 the Marshall family, Laurence and Lorna and their two children, John and Elizabeth, undertook their first journey to a part of the Kalahari known as Nyae Nyae. It is in north-eastern Namibia. Though amateurs, they had strong connections with Harvard University and together produced a comprehensive ethnographic collection that covered Ju|'hoan daily life, religion and rituals (Fig. 8). John's films of San life became widely known.

The Marshalls were followed by many other ethnographers who studied the Ju|'hoansi and other San groups, such as the G|wi, the !Kõ and the Nharo. They included Richard Lee, Irven Devore, Richard Katz, Megan Biesele, Mathias Guenther, Alan Barnard, George Silberbauer, and Marjorie Shostak. These

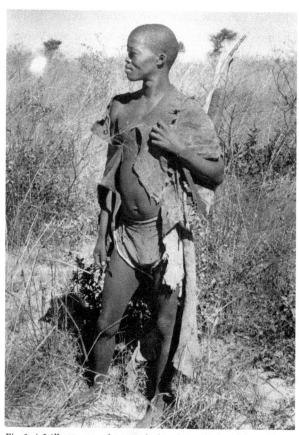

Fig. 8. A Jul'hoan man photographed in the 1950s by the Marshall expedition. He carries a bow and quiver.

researchers were not primarily interested in rock art. Indeed, the Kalahari San have no tradition of rock art, there being few places in the sandy Kalahari Desert where they could make images. The Tsodilo Hills in north-west Botswana are a well-known exception.

At first, students of the southern rock art rightly wondered if, given the linguistic differences and the absence of rock art, the Kalahari San would be of any use in understanding the southern images. It seemed best to concentrate on the Bleek family records and Orpen's article. But then remarkable parallels between the northern and southern San groups began to be found. It seemed that, despite the linguistic differences, certain rituals and beliefs were common to both. These commonalities included girls' puberty rituals, boys' first-kill observances and the San's central ritual, the only one that brings all the people together. It is variously known as the 'great dance', the 'healing dance' and the 'trance dance'.

A far-reaching conclusion eventually became clear. Despite initial misgivings, it is possible to use the Kalahari ethnography to expand and supplement the nineteenth-century southern ethnography *where continuities can be indisputably identified.* These continuities are not trivial. They have led researchers to propose what has been called a 'pan-San cognitive system'. This phrase has sometimes been

misunderstood. It does not suggest that all San groups are identical in all respects, merely that certain key beliefs and rituals are widespread.

Finding and turning an appropriate key

With so much ethnography available, the interpretation of southern San rock art may seem easy. Not so. Some researchers have combed the ethnography, especially that from the Kalahari which is in readily readable English, found an area of belief and ritual, and then imposed it on the art. Here we must again return to the two points I made at the end of Chapter 2. The fit between any ethnographic focus and the imagery must be demonstrated, not simply assumed. An obvious point emerges: the art does not reflect *every* component of San life and belief. Many important San beliefs seem not to have been painted. For instance, though |Kaggen, the Mantis, was the |Xam trickster-deity, no one has found a completely convincing depiction of a praying mantis. Rather, the images existed and had meaning within the mental background that San viewers brought to the painted panels. We have therefore to trace linkages between identifiable painted features and those encompassing beliefs and rituals that constitute the conceptual milieu of San rock art.

Now we come to the crucial, practical point. How do we identify instances of the fit between the

ethnography and the art? What, exactly, constitutes a 'fit'? The best way of answering this question is by demonstration. I therefore return to the figure in the South African coat of arms and use it, together with other images in the Linton panel, to show how the key to understanding San rock paintings may be turned.

4

Threads of light

The duplicated and reversed figure that now stands in the centre of the South African coat of arms is in the lower centre of the Linton panel. That position, of course, results from the way the slab was chiselled from the rock face. The whole panel was but part of a much larger panorama of paintings across the wall of the shelter. If the removed section is viewed as a whole, the standing figure is by no means prominent: there are at least four human figures that are considerably larger than it, and there are also some large, striking images of eland. But the figure was, for the San, not an insignificant, isolated part of the panel. As I have pointed out, it is linked to numerous other images by the thin red line on which it stands and which bends around its feet. This line, for the most part fringed with white dots, is clearly crucial to any understanding of what the painter, or painters, were trying to create with not just one but rather a whole range of images. What

are the principal characteristics of the line?

At the left side of the panel, a young eland is depicted walking along the line, which then enters the back of the neck of a supine human figure that has antelope hoofs (Fig. 2A). A short section of line joins this figure's left arm to a foreleg of another eland. Another section of the line comes from the figure's right ankle to the same eland's left hind leg, around which it appears to wrap. A small rhebok antelope stands on this section of the line; it bleeds from the nose. The line leaves the eland's leg and heads in the direction of another eland, but some flaking of the rock prevents us from seeing its entire length. Then the line leaves a front hoof of that eland and runs down to the top of the head of an elaborate standing human figure. It leaves this figure through its mouth and then bifurcates. One part runs down to the coat of arms figure and then on towards the right. The upper section runs via some animated human figures to the left arm of a second supine figure which is comparable to the one at the left of the panel. It wraps around the arm of this figure and then again branches, one section going down to join the lower part of the line, which sharply doubles back, while the other runs off the right edge of the rock slab. In some sections the feature is reduced to a series of parallel white dots, the central red line being omitted. In other sections, the white dots appear to have been omitted

(the parts that have only intermittent dots may be a result of the white paint flaking off, as it tends to do, though I consider this unlikely, the whole panel being so well preserved).

We can say that the line, viewed overall, seems to act as a path *and* as a rope or cord that wraps around limbs. In some other sites, human figures grasp the line with both hands. In addition, the way it enters and leaves humans and animals defies any naturalistic explanation: it seems to change character from something real to something unreal. We must surely conclude that the line does not depict anything in the material world.

But what effect does the line have on the panel as a whole? Whatever it may be, the line shows us that apparently unrelated images some distance from one another were, in ways that we may not at present fully understand, related. We can go a step further. The line suggests that the whole apparently jumbled Linton panorama, even if it was painted by more than one artist, is a conceptual unity. Certainly, it cannot be said to be a series of disparate vignettes of daily life, as some of the early rock art researchers may have supposed. Moreover, the line is not unique to the Linton panel: it is painted throughout the south-eastern mountains, that is, the Maloti of Lesotho and the Drakensberg of South Africa. In other parts of the subcontinent, such

as the Cederberg, a comparable line is also sometimes found, though less elaborately painted. Rather than being an idiosyncratic invention of a single painter's imagination, the line represents a widely held concept.

Yet, despite its unreality, the line is integrated with many images which seem to pose no such problems – eland and rhebok antelope, human beings and so forth that look, at least to our eyes, real enough. That is, of course, an assumption: images that show no signs of distortion may depict spiritual beings or animals. The coat of arms figure is another instance. As we shall see in this chapter, the nasal blood sweeping back across its face and the line at its feet point to an out-of-this-world experience, yet it looks real enough. A pivotal question in all this is: Does the non-reality of the line imply that the images that we may think are real are in fact also part of another realm of being?

Invisible potency

To explain the mystery of the line, we begin by going back to one of the early writers on the Kalahari San, the German ethnographer Viktor Lebzelter. In the 1920s he wrote: 'Finally the great captain in the sky hears the lamentation. The magician goes outside the camp and sees a thin cord being let down from the sky. He climbs a certain way up this, but the great captain comes down to meet him half-way. As soon as the

magician sees the great captain, he throws a powder up to him; whereupon the great captain lifts him up high and takes him into his house. There the magician prays to him: "Lord, help us, the children are dying, we thirst and hunger." So long does he pray and plead that at last the captain says: "It is well, I shall send water, that the children may have water and veldkos." Then he again accompanies the magician half-way down the cord. As soon as the latter has reached the ground, he releases his hold upon the cord, which is at once drawn up again. The rain follows immediately.'[19]

Here we at once see the problems of translation to which I referred in the previous chapter. For instance, we have to ask what 'the great captain in the sky' means. It seems to be a Western notion of a transcendent God but transmuted into a San way of thought – or at least into what a Westerner may imagine to be San thought. Then, too, 'magician', a key word here, is clearly inappropriate.

What exactly does 'magician' mean? The answer is within our reach, but it is not to be found in Lebzelter's Kalahari account. To get at it, we must go back to Wilhelm Bleek and Lucy Lloyd, in whose phonetic transcriptions we can find actual San words. In doing so, we allow that Bleek and Lloyd were working with southern, not Kalahari, San, but we also know that it has been clearly established that there were

distinct parallels between the beliefs and rituals of the southern and northern groups. As I mentioned in the previous chapter, these parallels can be empirically determined by comparing San ethnographies from the two regions. They exist despite obvious differences in ecology, climate and terrain.

In 1875 Lucy Lloyd showed a |Xam San man a copy of a rock painting that George Stow had made and sent to Cape Town. It shows a row of people, the leading figure of which holds a stick. It is a rather crude painting, not nearly as attractive as many others that Stow copied. The following is part of Lloyd's English translation of what the man said; Dorothea Bleek published it in 1930 next to a reproduction of Stow's copy. Whereas Lebzelter wrote about 'magicians', Lloyd used the equally unsuitable word 'sorcerer'. Her informant identified the procession of figures as performing a dance: 'They seem to be dancing, for they stand stamping (?) with their legs. This man who stands in front (1st figure to the right of beholder) seems to be showing the people how to dance; that is why he holds a stick. He feels that he is a great man, so he holds the dancing stick, because he is the one who dances before the people, that they may dance after him. The people know that he is the one who always dances first, because he is a great sorcerer. That is why he dances first, because he wants the people who are

learning sorcery to dance after him. For he is dancing, teaching sorcery to the people. That is why he dances first, for he wants the people who are learning sorcery to dance as he does. For when a sorcerer is teaching us, he first dances the 'ken dance, and those who are learning dance after him as he dances.'[20]

Before we tackle the problem of the 'thin cord let down from the sky' about which Lebzelter wrote, we need to go back to Lloyd's manuscript notebooks. There, we find that the |Xam narrator continued after the passage that Dorothea published and that I have given. In these additional pages, he gave further information about 'sorcerers' and what they did.

The |Xam word that Lloyd translated as 'sorcerer' is *!gi:xa*. We need to analyse it into its constituent parts if we are to understand the fundamental San beliefs that make sense of the Linton panel. The first syllable, *!gi:*, means 'supernatural power' or, the word I shall use, 'potency'. This potency is invisible to ordinary people. In itself, it is neither good nor bad, though in strong concentrations it is dangerous. Lorna Marshall, who worked with the Ju|'hoansi (as did Lebzelter), likened this potency to electricity: it can be harnessed for the good of people, but it must be respected and controlled. The Ju|'hoansi call it *n!om*. Potency is not a minor part of Ju|'hoan beliefs. On the contrary, it permeates much of their and other San groups' belief

and ritual: it is something about which the San talk a great deal. The same seems to have been true of the southern San. Indeed, even at this initial stage of our inquiry about the images in the Linton panel, we can say that we should not be surprised to find that an understanding of potency is essential to an 'insider's' account of San rock art.

Lloyd's |Xam San informant also used another word to refer to the dance that he believed to be depicted in Stow's copy as well as to potency itself. Dorothea gave it as 'ken, or, as Lloyd's notebook has it, ‖ke:n. (It was common at the time to substitute an apostrophe for the clicks that Westerners find hard to pronounce.) ‖Ke:n, too, means potency. The dance that the !gi:xa was teaching to those dancing behind him was known as the ‖ke:n. 'To dance the ‖ke:n' was '!kôä ‖ke:n'. This means to tread or stamp ‖ke:n.

According to the |Xam man, a person who can control potency is a !gi:xa. The second syllable, -xa, means 'full of'. A !gi:xa was thus a person who was full of potency; the plural form of the word is !gi:ten. Among the Kalahari Ju|'hoansi, these people are called n|om k'xausi, a phrase that means 'owners of n|om' (singular: n|om k'xau) (Fig. 9).

How then should we translate !gi:xa and n|om k'xau? There is no exactly parallel English word: 'magician', 'sorcerer' and 'priest' all seem inappropriate.

71

Some anthropologists who have studied the San prefer the word 'healer'. Certainly, healing is a significant part of what these ritual specialists do, but the southern San specialists did more than just heal: as we shall see, an important part of their work included rain-making and going on out-of-body journeys. Not without controversy, some researchers have therefore resorted to the Siberian word 'shaman', a term widely used by anthropologists. In Siberia, a shaman is one who learns how to enter the spirit world (a state of altered consciousness) and thus make contact with unseen beings in order to heal people, to achieve success in the hunt, to change the weather, and so forth. There are numerous parallels between Siberian shamans and ritual specialists in other parts of the world, such as those in North and South America. While there are also differences between shamans in different parts of the world, use of the word to denote southern African San ritual specialists does underline important similarities. So, rather than 'magician', 'sorcerer' or 'healer', I use 'shaman' to denote the San ritual specialists of whom the |Xam spoke and other San people still speak.

Another parallel between the Ju|'hoansi and the |Xam San is that people learn to become shamans by dancing behind an older and more experienced shaman. Lloyd's informant said that a 'great' *!gi:xa* led the dance; the learners followed after him. Gradually,

Fig. 9. A Kalahari shaman in trance photographed by Jürgen Schadeberg in 1959.

the novices learn how to master the 'rising' of their potency, as I describe the sensation in a moment. Many young San men try to become shamans but fail. No one blames them: after all, everyone knows that the spirit realm they are required to frequent is terrifying and dangerous. In the end, about half the men in a Juǀ'hoan band may be shamans and about a third of the women.

In the text that Lloyd's informant gave after the portion published by Dorothea Bleek next to Stow's copy, he spoke of a phenomenon that is key to understanding San rock art. We find it depicted in the Linton panel. 'When a sorcerer (*!gi:xa*) is teaching us,

his nose bleeds. He sneezes the blood from his nose into his hand. He makes us smell the blood of his nose, for he wishes its scent to enter our gorge (?); our gorge feels as if it were rising up because his nose's blood is making it rise. And when the blood has made our gorge rise, it feels cool as if cold water were in it.'[21]

The Ju|'hoansi also say that shamans bleed from the nose when they enter the spirit realm. Anthropologists seem never to have actually observed this happen, though the people do speak of it. When I was in the Kalahari in the 1970s with the American anthropologist Megan Biesele, I asked a Ju|'hoan woman what the *nlom k'xausi* did with their nasal blood. In response, she drew her fingers back from her nose and across her face, a gesture that would leave blood smeared back. The figure used in the coat of arms has, in its original form on the rock face, red lines radiating back from its nose (Fig. 3). Nasal bleeding is thus clearly associated with entry into the spirit realm.

Indeed, nasal blood appears elsewhere in the Linton panel. At the left, a spotted snake with an antelope head lies on its back and bleeds from its nose; the large, supine human figure has red lines on its face; and the small rhebok that has blood gushing from its nose also has lines on its face (Fig. 2A). Farther to the right, at least ten human figures are all bleeding from the nose, as well as some antelope. Clearly, we are dealing with

an important feature of both San experience and imagery. The painters of the Linton panel – and of so many other panels throughout southern Africa – depicted transition from this world to the spirit world by painting nasal blood.

The Dance of Blood

What else do we know about the ‖ke:n dance?

The oldest account we have was written as long ago as the 1830s by Arbousset and Daumas, when they were in what is now Lesotho: 'This is the only amusement known to the Baroas [San]; it is only practised when they have eaten and are filled, and it is carried on in the middle of the village by the light of the moon. The movements consist of irregular jumps; it is as if one saw a herd of calves leaping, to use a native comparison. They gambol together till all be fatigued and covered with perspiration. The thousand cries which they raise, and the exertions which they make, are so violent that it is not unusual to see some one sink to the ground exhausted and covered with blood, which pours from the nostrils; it is on this account that this dance is called *mokoma*, or the dance of *blood*.

'When a man falls thus out of breath in the middle of the ball, the women gather around him, and put two bits of reed across each other on his back. They carefully wipe off the perspiration with ostrich feathers, leaping

backwards and forwards across his back. Soon the air revives him; he rises, and this in general terminates the strange dance.'[22]

Many readers have wrongly concluded that *mokoma* means 'dance of blood'. It seems that the missionaries, too, may have misunderstood the Sesotho word *mokoma*. (Sesotho is the language spoken by the Basotho Bantu-speaking people; *mokoma* is not a San word.) It does not mean blood. In modern orthography *mokôma*, or *mokômê*, means 'great physician or doctor'. The dance may have been popularly known as 'the dance of *blood*', but the Basotho recognised that it was a healing dance. Their word *mokoma* shows not only that the dance featured specialist healers but also that the Basotho people themselves held San healers in high regard.

The tone of Arbousset and Daumas's description reflects the general colonial milieu: the natives' seemingly bloody rituals were thought to be disgusting. Yet, amidst all this revulsion, it became clear to the missionaries that dancing was more than an 'amusement'. To be sure, they enjoyed dancing (as they still do in the Kalahari), but there was more to it than mere pleasure.

In the Eastern Cape Province and eastern Free State, George Stow found unmistakable evidence for dancing in every camp and, significantly, every large rock shelter, the very locations where he found and copied

rock paintings. 'The universality of this custom was shown by the fact that, in the early days, in the centre of every village or kraal, or near every rock-shelter, and in every great cave, there was a large circular ring where either the ground or grass was beaten flat and bare, from the frequent and constant repetition of their terpsichorean exercises.'[23]

In the Kalahari today, San groups still regularly hold such dances. The women usually start the dance by singing special songs that are believed to contain potency. They then sit in a tight circle around a central fire, which, they believe, heats up the potency. The men dance in a circle around the women, now clockwise, now anticlockwise. Their pounding steps leave a circular rut in the sand, like those that Stow found. They tie dancing rattles made of cocoons or small, dried antelope ears to their lower legs, and they carry flyswitches. The San do not use these switches to chase away flies; they reserve their use for the dance. Some say that they use the switches to flick away the invisible 'arrows of sickness' that malevolent spirits of the dead are said to shoot into people. Both dancing rattles and flyswitches are depicted in the art. In the Linton panel, two figures, including the supine figure with hoofs in the upper left corner, hold flyswitches. Curiously, the large standing figure just left of centre has a flyswitch associated with its penis (Fig. 2C).

As the shamans' potency (believed to reside in their stomachs) begins to 'boil' they experience a tingling sensation rising up their spines. This is painful and causes the shamans to bend over with their bodies at right angles to their legs; they support themselves with one or two sticks. At the climax of this experience, the potency is believed to 'explode' in the dancers' heads and they are catapulted into the spirit realm – what researchers understand to be a state of altered consciousness. Their spirits are believed to leave their bodies through a hole in the tops of their heads. In the Kalahari today this state is not induced by the ingestion of psychotropic substances but by intense concentration combined with audio and rhythmic driving.

At this point, San shamans fall to the ground, sometimes cataleptic. They sweat profusely, tremble violently and emit shrieks. This is considered a dangerous condition: people fear that the spirit that has departed from the shaman's body may not return. They say that the shaman has 'died'; 'death' as transition to the spirit realm is the essence of San religion. When this happens, others rush to assist fallen shamans by rubbing them with sweat. Eventually, they gradually return to a more normal state, sometimes slipping into sleep as they do so. Some dances last all night, dawn being considered an especially powerful time. The next

morning, shamans tell people of their experiences in the sprit world.

Shamans accomplish the important healing process by controlling the level of their trance and, in that balanced state, the laying on of hands. In this way, they remove any 'arrows of sickness' that spirits of the dead and even malevolent shamans living in far-off camps may have shot into people without their being aware of their dangerous condition. They draw the 'arrows' into their own bodies and then expel them through a 'hole' in the back of the neck. Researchers have convincingly argued that certain grotesque white paintings depict spirits of the dead. There are some of these images in the lower right part of the Linton panel. The most typical one is just above the head of the coat of arms figure.

If 'death' is one way in which the San speak about trance, 'underwater' is another. A Ju|'hoan shaman told Megan Biesele: 'We travelled until we came to a wide body of water. It was a river … Then I entered the stream and began to move forward. My sides were pressed by pieces of metal.'[24] Being underwater and being in trance are analogous experiences: in both, there is a sense of floating, difficulty in breathing, sounds in the ears and affected vision. In their rock art, the San expressed this state by sometimes depicting fish. The supine human figure with hoofs in the top left

of the Linton panel is a case in point: it is surrounded by four fish and what appear to be eels (Figs. 2A, 2B; see also Fig. 11).

Whilst some circular dances are depicted in southern San rock art, other choreographies are also found. In some of these, the men appear to be dancing in the centre, while women stand and clap on either side. But we know that these are 'medicine dances' by distinctive dance postures that include bending forward at right angles, and the presence of nasal blood, dancing rattles and flyswitches. In one of the most significant and frequently painted dancing postures, human figures holds their arms in what appears to be a rather awkward backward position. Ju|'hoansi say that shamans sometimes adopt this posture when they are asking God to give them more potency. Some of these diagnostic features appear in isolation: for instance, a single human figure bleeding from the nose is sometimes found among depictions of animals. Such figures point to a fundamental relationship of San thought – that between animals, people and supernatural potency. It was not necessary to depict a whole dance 'scene' for the significance of the dance to be evident. It seems that the individuals' breakthrough into the spirit realm was a crucial component of painted panels.

Potency and trance manifest themselves in a

number of other ways. For instance, subjects in trance report experiencing an elongation of their bodies – a corollary of the feeling of rising up, attenuation and floating. This, too, is depicted in San rock art. Human figures, sometimes in the arms-back posture or bleeding from the nose, are painted in a markedly elongated way. In Fig. 10, three greatly elongated figures are in typical dancing postures.

I need to emphasise that the trance dance and its experiences are not peripheral optional extras for the San; dances and the experiences they induce are not rare, esoteric occurrences. *On the contrary, medicine dances are central to daily life and are frequently performed: the dance and its experiences suffuse San thinking.* The San medicine dance is the conceptual context that makes Lebzelter's report comprehensible.

Threads of light

When San shamans enter the spirit realm, a particular kind of vision closely parallels the painted line. They report seeing bright and iridescent sinuous lines along which they can walk or simply glide. They also treat these lines as ropes that they can grasp and climb as they ascend to the spirit realm in the sky. The lines they see can thus be both paths and cords. Researchers call them 'threads of light'. Before going up to the sky, some San shamans say they enter a hole in the ground, travel

underground for some distance and then emerge in another part of the country before they climb up to God's house in the sky. There they plead for the sick and entreat God to assist them in their hunts.

Old K'xau , a Juǀ'hoan shaman, gave Megan Biesele a detailed account of how he had learned to climb these lines. His 'helper' the giraffe (a source of great potency) came and took him and showed him the way. He followed a line that led him underground, through a subterranean river and up towards the sky. 'I take them and climb them. I climb one and leave it, then I go climb another one.' Biesele comments: 'Great attention is given to trancers' accounts of what they have experienced, and no one's account of a genuinely altered state is belittled … His listeners regarded it as an important piece of the truth and … I also regard it that way.'[25]

Some shamans speak of engaging with the threads of light in dreams. Sometimes a thread breaks, and a climber falls to earth: 'His body at home will just sleep.' Meanwhile the marooned shaman has to wait until it is dark again. He then makes his way back to his camp. But usually the threads hold. A Juǀ'hoan shaman exclaimed: 'Isn't the thread a thing of *nǀom*, so it just has its own strength? You learn to work with it.'[26]

We can now see that the painted line that passes through the Linton panel is a depiction of 'threads of

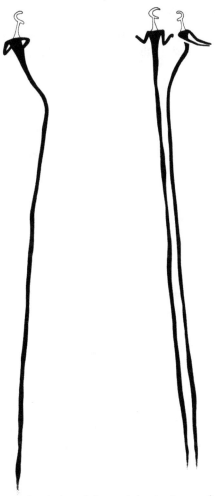

Fig. 10. A rock painting of elongated dancing human figures. The arms-back posture means that the dancer is asking God for more potency. (Harrismith district)

light'. It links shamans to the spirit world. In the next chapter we consider some more features of the line and try to answer the question why belief in it is so widespread.

5

The mind in the brain

I begin this chapter with some varied accounts that Kalahari San shamans have given about the 'threads of light' they see during a trance dance or in dreams. These personal testimonies give a vivid idea of what San religious experience was, and still is, like. As with all components of San religion, there is an element of idiosyncrasy – but within certain parameters. This is why the line appears in different forms in the paintings. Intriguingly, the descriptions that the San give of the line, though varied, seem to suggest something more 'real' than simple imagination. It and other spirit world things are *experienced*, not just imagined, and shamans say that they actually engage with them.

Seeing the threads
First, we must establish who sees 'threads of light' and in what circumstances. Significantly, the threads or ropes are not visible to ordinary people. A Ju|'hoan

man was explicit: 'If I want to learn to climb the threads to God's village, first of all I have to learn to heal people. After that, the healers will teach me how to use that thread.'[27] Learning to heal means learning to enter an altered state of consciousness at a trance dance, that is to say, becoming a shaman. The rock paintings that depict 'threads of light' thus manifested inner experiences not open to ordinary people.

San shamans report seeing lines of different colours and forms. Some refer to 'chains' rather than ropes. One said: 'Some chains have circles or dots on them. Those are the steps you climb up to the sky. Some of these steps are white and shiny, while others are red … You may see it as made of pieces of ostrich egg shell. Each piece is a step that you can climb to the sky.'[28] These remarks tie in remarkably well with those painted lines that are fringed with white dots: the dots may represent mystical ostrich eggshell pieces that are sometimes seen to be part of the line. Then, too, it is occasionally painted in red and white segments, or 'links'. In the painting shown in Fig. 11, the sectioned line relates to the sort of mystical creature that I discuss in the next chapter. In this complex painting a number of human figures bleed profusely from the nose, and, curiously, a pair of human legs emerge from a segment of the line that seems to double as the figure's body.

A key point is that the lines can enter a shaman's

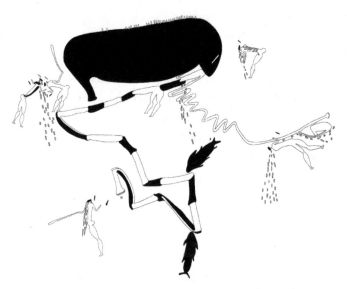

Fig. 11. A rain-animal associated with a 'thread of light' painted in red and white segments. Human figures bleed from the nose. The fish indicate an underwater context. (Eastern Cape)

body. One Juǀ'hoan man said: 'The ropes go to the top of your head and to your stomach. They pull your body up and down.' Another man said: 'When I get close to the fire, the smoke hits me and I suddenly start climbing the rope. When this happens I feel a little hole open at the top of my head.'[29] Here, we think of the prominent male figure in the Linton panel that stands to the left of the one used in the coat of arms. The line passes in or out of the top of its head and also through its mouth (Fig. 2C).

In addition to providing access to the spirit realms below and above the earth, the lines play a part in hunting. One Ju|'hoan shaman said: 'There is a line, like a rope, from the animal that connects to your arm … When you see the line, it hooks up to your arm and pulls on it. That's when you know you are connected to the animal. You know without a doubt that you will kill that day.'[30] In some paintings, a hunter is shown connected to an antelope by the line. In the Linton panel, it clearly joins people to animals and wraps around the antelopes' legs, as if it were hobbling them (Fig. 2B).

The experience of the lines is not necessarily a solitary affair. As in the dance itself, shamans co-operate when they climb the ropes. One Ju|'hoan shaman described how he met others on a journey to God's village to heal a girl. 'We climb together, helping each other along the way … As we began to climb back down the threads [after successfully pleading with God], we met Tshao Matze and |Kaece on the way. They were also trying to go to God's village to help save that little girl. We told them not to worry, that we had done the work … We all travelled back together.'[31] It is therefore not surprising to find a number of human figures and animals associated with lines in the paintings. The lines unite people on their spiritual journeys.

Portals to the spirit realm

In the 1960s the psychologist Richard Katz, who studied Juǀ'hoan shamans, found that an opening through which they enter into what he called 'the inner world of mysteries' is an important part of experiencing the 'threads of light'. This 'opening' is the threshold, the liminal area, between the material world and the spiritual world 'beyond'. Juǀ'hoan shamans also told Katz that, having entered trance (ǃaia), they follow a path to an opening through which they enter the spirit realm.[32] Similarly, a Juǀ'hoan shaman told another psychologist, Brad Keeney, that shamans follow one of these threads or paths to what he called 'a big hole' leading to the spirit world: 'My teacher showed me the line to the underground hole.'[33] Old K'xau, who told Megan Biesele how the giraffe, his helper or 'protector', took him on a spiritual journey, explained: 'Then my protector told me that I would enter the earth. That I would travel far through the earth and emerge at another place.'[34] Long before these reports were recorded in the Kalahari, one of Bleek and Lloyd's informants, himself a nineteenth-century ǀXam San shaman, spoke of 'a Bushman's path' that led to a hole in the ground: at death, people followed this path to the spirit realm.[35]

These experiences bring us to a key feature of the painted line that is not shown on the Linton

panel. In many panels, the line enters cracks, steps or other inequalities in the rock face (Fig. 12). It then emerges at another place before continuing its route through the images. This feature of the line is clearly consonant with San shamans' reports of passing underground. The shamans' experience of moving along a line and then through an opening was transferred to the medium of painting: passing underground is exactly what the painted line appears to do. Moreover, it is not only the line that appears to enter and leave the rock face: depictions of animals and people are also painted so as to appear half in and half out of the rock face. These images show that the San believed the rock face to be permeable and that the spirit realm lay behind it.

Transformation

To gain access to the line and the opening through which it passes, shamans 'slip out of their skins'. After sloughing off their human form, they sometimes turn into lions or other animals in order to travel more rapidly. One Ju|'hoan man put it like this: 'You feel like the wind. Your breath turns into an animal, and your soul (*moa*) changes.'[36] Another described this transformation taking place as the dance proceeds. The central dance fire is believed to heat up the shamans' potency. 'There are times when we stare into the fire

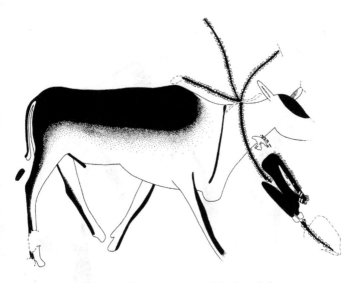

Fig. 12. 'Threads of light' converge on a notch in the rock face. A shaman in the arms-back posture kneels on the line. Three segments of the line emerge from inequalities in the rock. An eland is painted so that the central, elongated notch is at the back of its neck, the spot from which shamans eject sickness. (Eastern Cape)

and the fire seems to get larger and larger until it covers everyone. When this takes place, you may look and see an animal appear in the fire. It can turn you into that animal … When you see the animal in the fire, it changes you. You become that animal.'[37]

Changing into an animal is a profound experience intimately associated with the trance dance. It is therefore not surprising that there are many therianthropic figures in the art – they are part human and part animal, often with an antelope head and

91

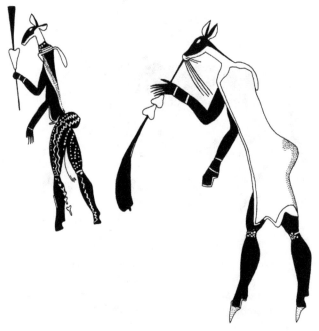

Fig. 13. Two human figures with antelope heads and hoofs. One bleeds from the nose; the other has zigzags on his legs that trail off into heart-shapes. (KwaZulu-Natal Drakensberg)

clearly painted cloven hoofs (Fig. 13). A few even have elephant heads. 'Threads of light' are often associated with these figures and thus link them to trans-cosmological travel.

There has, however, been much debate about these figures. Earlier researchers sometimes argued that they depict hunters wearing antelope masks. But the heads clearly merge with the bodies, and the hoofs are clearly

transformations, not 'shoes'. In any event, they are not part of hunting scenes; commonly, they are in dancing contexts. More plausibly, some researchers believe that they depict spirits of the dead or people of the mythical Early Race, which was believed to have preceded the present-day San. If these two suggestions have any merit, we must allow that the nasal blood, arms-back posture and 'threads of light' so often associated with them show that they are not ordinary spirits of the dead but rather dead shamans of the Early Race. We are thus led away from simple, depictive 'mythological' explanations and back to the complex experiences of San shamans.

We can now inquire into the origin of this concept of 'threads of light' and the 'holes' to which they lead. Why are the 'threads' such a pervasive feature?

The human brain

Another controversial aspect of San rock art research is the part that the human brain plays in altered states of consciousness. Some researchers believe that human 'imagination' accounts sufficiently for the experiences that San shamans report and that it is not necessary to invoke altered states.

The counter-argument runs as follows. We know that San shamans enter an altered state of consciousness in the trance dance. That is beyond dispute. We also

know that this dance is the most frequently performed San ritual. Moreover, everyone comes to a dance, because they believe that, in it, the shamans make vital contact with the spirit realm. When food is abundant, the people may dance a number of times each week. It is therefore important to realise that altered states of consciousness are something that all San encounter frequently: *those states are not exceptional or outlandish, as they are for most Westerners – including rock art researchers.*

Ordinary people take an interest in what they observe at dances and what the shamans tell them. Biesele found: 'Great attention is given to trancers' accounts of what they have experienced, and no one's account of a genuinely altered state is belittled … Through the physical and artistic discipline of the highly structured dance, an altered state of consciousness is produced in some participants which has benefits for the entire community. Contact with the beyond is regularly made, and all who come to the dance experience an uplifting energy which they feel to be a necessary part of their lives.'[38]

Everyone witnesses and to a certain extent shares in the total experience. Then, after a dance, the people listen intently to the shamans as they recount their experiences. Katz and his co-authors, like all San ethnographers, emphasise the importance of these

accounts for everyone: 'Though a degree of cultural patterning is present in many healers' accounts of travels into the spirit world, the Ju|'hoansi treat these experiences as unique messages from the beyond. Because these journeys are accessible in no other way than through *!aia* [altered consciousness], narratives of these experiences are regarded as valuable documents.'[39]

Although these 'unique messages' are each valued for their individuality, the San themselves recognise the fundamental similarities – the 'cultural patterning' – of their spiritual experiences. A Kalahari shaman remarked explicitly on this commonality: 'Every Bushman medicine person sees the same thing in the spirit although we may each go into the spirit in different ways.'[40] The 'messages' are personal variations on a divine theme.

If we grant that altered states of consciousness are common and also centrally important to the San, we should surely go on to study what is known about those states and what people generally experience in them. Fortunately, psychologists and neuropsychologists have studied how the human nervous system behaves when it enters an altered state, and we can consult many publications on this subject. Our starting point is that, because the San's nervous system is the same as everyone else's, their experiences follow the same

general course or pattern as experienced by Western laboratory subjects engaged in neurological research. I say 'the same general course' because, whilst the *structure* of those experiences is universal (like the human nervous system itself), the *content* varies according to culturally controlled expectations. At a fundamental level, it is clear that an Inuit person may hallucinate a polar bear, but a San person will 'see' an eland.

Beyond that sort of variation in content, neuropsychological studies have shown that certain specific visual percepts and the progression, or stages, of altered states are 'wired into' the human brain and that all people, no matter what their cultural background, have the potential to experience them. This commonality of experience in altered states of consciousness is, in general terms, true whether the state is induced by ingestion of psychotropic drugs, intense meditation, sensory deprivation, audio and rhythmic driving, pain, certain pathological conditions (including temporal lobe epilepsy and migraine) and so forth. Now, because San rock art deals, in large measure, with San religious experiences or, as Biesele explicitly describes that experience, the 'hallucinations of actual *nlom k'xaosi*', we can expect the results of neuropsychological research to clarify some (though by no means all) features of those experiences.

In a slightly simplified version, neuropsychologists have shown that the trajectory of an altered state develops as follows. In an early, or light, stage of altered consciousness all people have the potential to experience a range of luminous, fleeting, geometric visual percepts, the forms of which derive from the neuronal structure of the brain. As they pass into a 'deeper' altered state of consciousness, subjects often feel themselves drawn into a vortex, tunnel or narrow hole. This is the frequently reported near-death experience of a passage with a bright light at the end. The vortex leads into the final stage of trance – another world with its own rules of transformation and causality. In the deep trance of this final stage, they hallucinate animals, monsters, people, people turning into animals, and complex situations in which they themselves participate. Importantly, they become part of, and participate in, their own hallucinations. The bright geometric forms of the first stage are now peripheral or integrated with other hallucinations: for instance, a human being may be partly (or indeed wholly) a zigzag (Fig. 13). In this deep hallucinatory stage, partial or complete transformation into an animal or other form is also a common experience. These stages of trance are not inescapable: some people are catapulted directly into the 'deep' stage and do not experience the geometric forms of 'light' trance.

Others experience them but dismiss them as 'noise' before the real thing begins.

Already, we can see parallels between the results of neuropsychological research and the San shamans' reports of their experiences. But let us now go further and examine more closely the 'visions' of early, or light, trance. The geometric percepts of this stage have been called 'subjective light patterns', 'phosphenes', 'entoptic phenomena' and, because they are 'constant' for all human beings, 'form constants'. They are independent of an external light source. Gerardo Reichel-Dolmatoff, who studied entoptic phenomena (as we shall call them) in the visions of South American Tukano shamans, emphasised the significance of the neuronal 'wiring' of these subjective percepts. 'The perception of these patterns is entoptic, that is, they are not the result of mere visual, retinal observation, but are generated mainly in the neuronal system which includes the retinal ganglion network together with the cortical and subcortical range. Being thus originated within the eye and the brain, these light patterns are common to all men; they are inbuilt.'[41]

These 'inbuilt' entoptic phenomena include bright, pulsating zigzags, grids, clouds of dots, catenary curves, and webs. Significantly, two of these forms are described as luminous filigrees and 'endless chains of brilliant white dots'.[42] The 'threads of light' that San

shamans frequently report seeing in their altered states of consciousness inevitably come to mind.

Although all people have the potential to experience the full range of these geometric percepts, culturally created expectations cause them to value some and disregard others. There is thus an interplay between neurologically generated forms, which are, so to speak, the 'raw material' generated by the brain, and socially constructed selectivity and the ascription of meaning to them. They 'mean' different things in different cultures.

Again, I must insist that there is no neurological imperative:

- San shamans had the neurological potential to see the full range of entoptic forms.
- They were not neuronally forced to fixate on any particular entoptic form.
- Some San shamans nevertheless concentrated on, sought and frequently spoke about entoptic luminous filigrees and 'endless chains of brilliant white dots'.
- They ascribed culturally controlled meaning to them ('ropes' leading to God, other people and animals).
- They adapted, individually and to a degree idiosyncratically, that meaning to accord with

other, contingent experiences and their own immediate social circumstances.

All San shamans, no matter where they live in southern Africa, have the capacity to 'see' luminous filigrees and 'endless chains of brilliant white dots'. When learning to be a shaman or during subsequent trance dances, San shamans draw the attention of their fellows to what they 'see', and their visions thus become shared – and more powerful. Seeking and finding the 'threads' among the full range of entoptic elements were thus not only assured by the individuals' nervous systems but also culturally directed. They were led by cultural expectations to ignore some elements and to concentrate on others – that is, the 'threads' that they had been taught to believe led them to God, animals and so forth. Indeed, a Ju|'hoan shaman emphasised the importance of 'threads of light' in the learning process: 'In his commentaries the shaman explained that these glowing threads constitute a communication between the beholder (in this case the initiate) and the ecstatic dimension he is about to enter.'[43]

Rock art researchers who ignore neuropsychology, an independent and obviously relevant line of evidence, are being short-sighted and obscurantist.

Through the veil

I have shown that San shamans speak of 'threads of light' taking them through a hole that leads to the spirit realm. Moreover, 'threads of light' are frequently painted to give the impression that they are entering or leaving cracks, notches or other inequalities in the rock face. These two indisputable points, together with the way in which some images of animals and people also appear to enter or leave the rock face, lead us to conclude that, for the San, the walls of rock shelters were a kind of 'veil' suspended between the material world in which everyone lived and the spirit world to which shamans journeyed. In this way, the painted rock shelters themselves were gateways opening on the far reaches of the San cosmos. On a macro-scale, the rock shelters were the 'holes' that led to the spirit world, while, on a micro-scale, the small notches in the rock face were the actual entry points.

A San person, shaman or not, looking at the wall of a rock shelter could follow the painted line from animal to animal and then through an opening in the 'veil' to the world beyond. So many of the paintings show what shamans experienced in that 'behind-the-rock' spirit realm: they include transformations of people into animals and strange creatures. A striking example

is the Linton spotted snake with an antelope head that bleeds from the nose (Fig. 2A). There is an explanation for this especially curious image. The spotted rinkhals snake feigns death when it is attacked: like the painted one, it turns on its back, exposing its white underbelly, and lies as if its back is broken. When the aggressor approaches, it springs to life and strikes. The bleeding snake is thus probably a metaphor for a 'dying' shaman who returns to life. And snakes, of course, enter into and emerge from holes in the ground: they move between realms. The old shaman who told Biesele so much about underground journeys to the spirit realm made transformation into snakes explicit: 'If you're a snake, my friend, you'll stay alive. If you're a mamba, you'll stay alive.'[44] Not surprisingly, painted serpents are commonly depicted entering or leaving cracks in the rock face.

One of the shamans' tasks was to visit the spirit realm and then, if they were painters as well as shamans, to recreate on the rock face what they saw behind it. The rock was rendered diaphanous. It was not a meaningless *tabula rasa* on which anyone could depict whatever he or she wished, as Westerners might suppose it to be, but rather a meaningful interface between realms. Whatever people painted on it was situated in a context that related paintings to spiritual experience. As people participated in their own

deep trance hallucinations, the painted panels with their meandering 'threads of light' invited people to participate, even if vicariously, in the spirit realm.

6

Capturing the rain

In 1874 Wilhelm Bleek wrote: 'A Bushman painting will frequently help us to unearth a myth, legend, or fable, which otherwise would have been forgotten, and might have remained unrecorded.' More than that, he found a two-way pattern of illumination and wrote that what he called San 'mythology' and copies of their rock paintings 'will serve to illustrate each other'. Just such a case began to emerge when Bleek showed one of his |Xam informants a copy that Joseph Orpen had made in the Maloti Mountains.

This painting shows two quadrupeds of no identifiable species (Fig. 14). A group of four men is leading one of the creatures by means of a rope attached to its nose. Just below this group two men with spears confront a second quadruped. Comparison of Orpen's copy with what remains of the images in the rock shelter shows that the lower animal is in fact by far the larger of the two. Moreover, numerous flecks

of red paint, some of which are still visible on the rock face, are scattered amongst the images in Orpen's copy; unfortunately, they were omitted when the printer prepared the copy for publication. But, all in all, we can say that the copy that Bleek showed the |Xam man was accurate enough for us to be able to accept what he had to say about it.

It was on 21 June 1874 that Bleek started recording his informant's remarks. But he seems to have been baffled by what he was hearing. What could all this about attaching a rope to a 'water cow', the |Xam informant's phrase, possibly mean? He broke off writing down his translation on the second page, presumably so that he and Lucy Lloyd could discuss the meaning of what they were hearing. At the point where he suspended his translation he entered a note saying that the events that the |Xam man was describing appeared to him not to be 'literal', adding that 'the sense is apparently the reverse'[45] – though he did not know exactly what 'the reverse' was.

A couple of days later Bleek received Orpen's accompanying article. It contains the explanation that his guide Qing gave for the painting. We are thus able to compare two independent explanations of the painting given by San men from different parts of southern Africa. When further copies made by George Stow of Eastern Cape and eastern Free State

Fig. 14. J.M. Orpen's copy of a painting showing the capture of a 'rain-animal'. The objects held by the men are probably containers with aromatic herbs believed to calm the animal. The copy was made in 1873.

rock paintings arrived in Cape Town, Bleek's |Xam
people identified more instances of 'water cows'. Each
is in some ways unique, but they all clearly represent
the same concept. In the end, these curious paintings,
so baffling at first sight, came to be amongst the best
attested components of San rock art.

The rain and its animals

The |Xam phrase that Bleek's informant used to denote
the strange painted creatures was *!khwa-ka xoro*. The
first part of the phrase, *!khwa*, means both rain and
water, but it is |Xam beliefs about rain that we must
examine. The |Xam recognised two kinds of rain. A
violent thunderstorm was said to be a 'male rain', while
gentle soaking rains were known as 'female rain'. In
the interior of southern Africa rain comes usually in
the form of isolated 'male' thunderstorms. The San
feared these storms because they sometimes blew
down their flimsy shelters. Nevertheless, when they
saw a thunderstorm in the far distance across the vast
semi-arid interior plains, they longed for it to move in
the direction of their own camp. For them, rain was
life. When it fell, tubers that had lain hidden beneath
the parched land sprang up, and the veld was renewed.
Then antelope were attracted to the new grass and
bushes. Speaking of the much desired 'female' rain, a
|Xam man put it like this: 'She will rain softly on the

ground, so that it will be wet deep down in the middle. The bushes will sprout and become nicely green, so that the springbok come galloping.'[46] Rain changed the life of the San, and the connotations of the |Xam word *!khwa* were thus different from those of the English word 'rain'.

The rain was also spoken of as if it were a person or being. It could be offended. If it was, it became violent. The |Xam said that it 'attacks the hut angrily, and the hail beats down on us breaking down the huts, and the cold wind gets in to the people in consequence'. Misfortune awaited any man who offended the rain: 'The man, because of whom the rain is angry with the people, is the one whom the wind first lifts up, and blows up to the sky. Then he goes floating about in the sky, then floats out of the sky and drops down into a pond, then he stays in the pond and becomes a frog.'[47]

The last word in the phrase *!khwa-ka xoro* means any large animal, such as a cow or ox; the suffix *–ka* forms the possessive case. The San in the eastern parts of the subcontinent were familiar with cattle owned by Bantu-speaking farmers and possibly Khoe-speaking herders. The whole phrase thus means 'large animal of the rain/water'. These animals were, like the rain itself, of two kinds. A rain-bull was the fierce thunderstorm, while a rain-cow was the gentler, soaking rain that often set in for some days.

Taking the parallels between rain and animals further, the |Xam named different parts of clouds after parts of an animal: columns of falling rain were called the rain's legs, while wisps of cloud were known as the rain's hair; mist was said to be the rain's breath. The thunderstorm was said to walk across the country on its 'legs'.

Controlling rain

Closely allied to the *!khwa-ka xoro* were *!khwa-ka !gi:ten* (sing. *!gi:xa*). We have already encountered the second part of this phrase: it means a shaman, one who is full of *!gi:*, that is, supernatural potency. The Bleek and Lloyd manuscripts suggest that these |Xam rain-controllers were mostly men, although women could be other kinds of *!gi:ten*. There is only one record of a female *!khwa-ka !gi:xa*.

The *!khwa-ka !gi:ten* were said to capture a *!khwa-ka xoro* at night in a deep pool. They did this by throwing a rope or thong over its horns. They then led the creature across the country to the place where rain was needed or to the top of a nearby hill, and then killed it so that its blood and milk fell as rain. If they did not take precautions, the rain-animal could break the thong and escape. Capturing the rain was a risky business. There was, however, a way of calming an angry rain. 'You do not seem to have remembered

when you are seizing the water, that you should put *buchu* [aromatic herbs] on the things; you should have given the men who crept up with you *buchu*, so that they smelt of *buchu*. (If the bull had smelt *buchu*, it would have been calm and gone quietly without struggling.)'[48]

A discrepancy between Qing's statement that the flecks among the images 'are things growing under water' and Bleek's informant's view that 'The strokes indicate rain' can be explained. The two men were thinking of different stages in a rain-making sequence. Qing thought that the painting depicted the capture of a rain-animal in a deep pool or river and therefore interpreted the strokes as some sort of aquatic plant. The |Xam man imagined a later phase in the rain-making ritual when the people were leading the animal across the country, the rain falling as they went.

The relationship between both kinds of rain and the *!khwa-ka !gi:ten* is crucial to understanding the activity of rain control. One |Xam man spoke about a *!khwa-ka !gi:xa* named ||Kunn, who was in fact his grandfather. The old man died between 1870 and 1873, but, when the informant was a child, he saw him and experienced his rain. We thus have here a first-hand account of a *!khwa-ka !gi:xa*. The informant said that '*his* [emphasis added] rain came streaming from out of the west there, it went to the north, because he was

from that part'.[49] In another instance, it was said of a *!khwa-ka !gi:xa*, '*your* rain feels that you do not speak hastily. Therefore, *your* rain leaves off thundering and falls gently' (emphases added). Both these statements imply that a rain-controller possessed a specific, recognisable rain and that it was sometimes associated with the part of the land where he lived.

Bleek's oldest informant and himself a *!khwa-ka !gi:xa*, ||Kabbo (the name means 'dream'), spoke of a respected *!khwa-ka !gi:xa* who seems to have had the power to capture and kill either a rain-bull or a rain-cow, as he chose. But his preference was clear: 'I think that I will cut a mother rain that has milk, she moistens softly, her wind blows gently. She rains gently, because her clouds are soft.'[50] Although an association between a *!khwa-ka !gi:xa* and a specific kind of rain rather than merely rain in general was repeatedly confirmed, some rain-controllers were able to exercise a measure of choice in the matter.

In view of the close association between a rain-controller and a particular rain, it seems that, in many instances, a rain-controller was associated with, and in all probability actually painted, a particular depiction of his own *!khwa-ka xoro*. A man could point to a painting of a *!khwa-ka xoro* and claim that it was *his* rain. That is why each painted rain-animal is in some measure unique, while at the same time being clearly

Fig. 15. A rain-animal associated with a 'thread of light' and fish. (Eastern Free State)

a rain-animal. It does not follow that every painter was a shaman, or that every shaman was a painter. Nevertheless, the act of rock painting was closely associated with *!gi:ten* and the whole process of image-making was steeped in ritual, as I show in the next chapter.

This ritual context was characterised by the activities of San shamans. We may therefore wonder if the thong that rain-makers were said to throw over a rain-animal's horns was in fact another interpretation of a 'thread of light'. There are indeed paintings of

rain-animals that are clearly associated with 'threads of light' that seemingly come from their noses. Some of these are associated with fish to indicate that they are underwater (Figs. 11, 15). Paintings like these are comparable to those that show shamans connected to antelope by 'threads of light': the line is the means by which both antelope and rain-animals could be controlled.

Rain-control locations

A study of rain-making gives us some valuable insights

into the social life of |Xam bands. Many ethnographers have emphasised the essentially egalitarian nature of San society: no one appears to be richer or more powerful than anyone else. They have no chiefs and decisions (such as when to move camp) are communally taken following free discussion. But the activities of |Xam rain-makers give us new insights into how San shamans were regarded, even if they were in no sense wealthier or more overtly respected than other people.

Visiting between camps is a common feature of San life. Sometimes people undertook these journeys to solicit the aid of a rain-maker. In one instance, a |Xam informant spoke of people leaving early in the morning in order to reach the camp of a well-known rain-maker. Such journeys were dramatisations of a rain-maker's social influence: suppliants had to travel to him. He was important.

This point brings us to the location and nature of rain-making sites. One rain-maker said that he would 'ride the rain up the mountain on top of which I always cut the rain'.[51] The word 'always' suggests that this *!khwa-ka !gi:xa* had a specific, remote place to which he customarily went for his rain-making activities. Another |Xam man spoke of rain-makers killing and cutting up a rain-animal away from the camp. The rest of the people were at home when this happened, but

they were watching the sky, and eventually saw that the *!khwa-ka !gi:ten* 'really seem to have their hands upon the rain-bull, for you see the rain clouds come gliding.'[52] Later, the rain-makers returned to the camp.

These reports raise interesting questions about the locations of painted rain-animal sites. Most San rituals are conducted in their camps. For example, when a Ju|'hoan boy's coming-of-age scarification takes place after he has killed his first large antelope, the women, who should not see what is happening, simply leave the camp. (The isolation of boy initiates, now sometimes practised, seems to be an idea recently borrowed from neighbouring Bantu-speaking agriculturalists.) Similarly, when a girl's puberty dance is held, the men leave the camp. The most important ritual of all, the trance dance, also takes place in the camp, but everyone is present. Most San rituals are thus not performed away from the place where people live their daily lives.

While numerous rain-animals are painted in large sites where there are many other paintings and ample living space, there are other rain-animal sites that are small and isolated and have little or no living space. It is probable that these are sites to which rain-makers repaired when they wished to make rain out of sight of others. As such, these small sites were probably believed to be invested with special rain-control potency, and hence social importance. Each painted site was an

element in a network of ritual locations that linked the various bands living in the extended landscape.

In this way, rain-making differed from other shamanistic activities, such as healing, that were conducted in the camp where everyone could watch or take part. In many vastly different societies, knowledge of spiritual things is closely guarded and thus a foundation for social discrimination. But with the San it was not so much the knowledge itself that was secret (San shamans talk freely about their experiences in the spirit world) as the means of obtaining it: trans-cosmological travel by means of altered states of consciousness was not available to everyone. By travelling to an underwater realm, shamans had direct access to knowledge about rain-animals and rain-making procedures, whereas everyone else could access that knowledge only through the shamans. It was access to knowledge rather than its content that mattered. Secrecy associated with a remote place probably contributed to the San's ambivalent attitude to rain-makers: they feared and respected at least some of them.

In the nineteenth century, and probably before that as well, Bantu-speaking farmers employed the San to make rain for them. They sometimes paid them with cattle. The Bantu-speakers came to respect San shamans and on occasion sent their own ritual

specialists to the San who lived in the Drakensberg to learn mystical techniques. Through prolonged contact and intermarriage, the southern Nguni Bantu-speakers absorbed clicks into their language and took over the San word *!gi:xa,* which became *igqirha,* usually translated as 'diviner' (in Bantu languages the palatal click is represented by *q* and the guttural sound *x* by an *r*).

These thoughts about the importance of rain and rain-making lead us to wonder about the actual making of a painted image. Was the painting of an image as much a ritual as the trance dance itself?

7

Making an image

Today it is still unfortunately easy for those who do not know much about San religious beliefs and rituals to revert to Arbousset and Daumas's view that San rock paintings were simply 'innocent playthings'. For some, the very phrase 'Bushman paintings' is dismissive. Even if modern viewers of the art accept that much of it was religious in nature, many give little thought to the events that must have preceded and accompanied the making of an image and, just as importantly, the role that the images played in San life and thought after they had been painted on the walls of rock shelters. The complexity of the art is unknown to them.

The production of San rock art and its social impact were embedded, as indeed are all arts, in the social, economic, political and intellectual circumstances of the community in which the images were made. Like many other things that people make, San rock art did not merely reflect the society in which it was made: for

instance, there are many more paintings of men than women, and food gathering by women is seldom if ever portrayed. On the contrary, like all art, the images constituted, reproduced and sometimes subverted social relations and beliefs. To understand the power of painted rock art images it is necessary to situate them in the social and ritual milieu of their time.

The previous chapters have shown that San rock art comprises a range of motifs, most of which are referable to one or other aspect of San shamanism. Neither the art nor San shamanism is monolithic. The depictions include:

- Trance dances showing men and women in various choreographies
- Isolated shamans identifiable by a number of features, postures and gestures; isolated women in a clapping posture
- Animals, such as the eland, that were, amongst their various associations, considered sources of supernatural potency but were not necessarily visionary
- 'Scenes' that appear to record historical events but sometimes incorporate shamanic elements which suggest another level of understanding
- Various activities that shamans conducted in the spirit world, such as out-of-body travel

and the capture of rain-animals.

- Shamans partially transformed into animals
- Much more rarely amongst the paintings, as opposed to the engravings (for unknown reasons), geometric motifs, such as 'threads of light', that probably depict entoptic phenomena.

Even with this wealth of highly diverse evidence, it would be wrong to assume that each and every San rock art image necessarily derived from a specific vision. Similarly, it would be wrong to assume that every San rock art image was made by a shaman.

But a question remains in some people's minds: Is this explanation, despite its diversity, still too 'narrow'? Could some San image-makers have made paintings and engravings for completely different reasons? Without denying the explanations that I have outlined in previous chapters, some have argued that the art is concerned with potency in general and not just as it is manipulated by shamans. Others think that there may be a few images that are purely 'historical' (a complex, culturally situated concept that opens up difficulties that its advocates fail to address).

A principal problem with these and other explanations is that it is not possible to identify categories of images that can be confidently ascribed

to them. So many explanations fall down when the imagery itself is taken into account. In any event, the suggestion that San rock art dealt with a whole range of issues rather than just shamanism and its wide-ranging manifestations is based on Western concepts of art and picture-making, practices which indeed serve different purposes, both sacred and secular. We are back to 'reading' the art as if it were Western in its content and functions. 'Art' is not a universal concept; rather, it varies from culture to culture. As research progresses, the southern African evidence, painted and ethnographic, seems increasingly to suggest that San image-making was a focused ritual every bit as much as, say, the medicine dance or marriage. When we consider what we know about the actual making of images, we are again led back to the complex and multi-faceted, yet coherent, explanation that I developed in previous chapters where I showed how components of the ethnography 'fit' the imagery.

To come to grips with these issues, I identify four stages in what we may call the production and consumption of San rock paintings.

Stage 1: The acquisition of imagery

There were a number of contexts in which San shamans acquired insights that could become the 'raw material' for painted and engraved images: the trance dance,

special curing rituals that did not entail a large-scale dance, dreams, and, we may add, viewing rock art.

When a number of shamans are in an altered state during the course of a present-day trance dance in the Kalahari, one may draw the others' attention to what he (or she) believes he (or she) can see, perhaps a number of spirit-eland standing in the semi-darkness beyond the light of the fire. The others look in the direction indicated, and then they too see the same visions. There is thus a sharing, or pooling, of insights that makes for commonality of visions. Moreover, the describing of visions after everyone has returned to a normal state of consciousness is a further powerful influence on what people 'see' in future trance experiences. People tend to hallucinate what they expect to hallucinate.

At the same time, there are forces pulling in the opposite direction. No matter how powerful the informing social influences may be, the human brain in an altered state of consciousness frequently produces novel, or aberrant, hallucinations. Most people worldwide ignore these sports of the human nervous system because they are seeking specific kinds of visions that they can understand and that will make them feel they are part of a social group. But some do seize upon hallucinatory novelties and then present them as specially privileged insights that set them above others or, more forcefully, that challenge

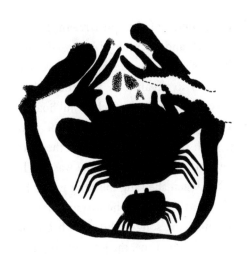

Fig. 16. A unique painting of a pair of crabs. One has lost its pincers. (Harrismith district)

the whole structure of power relations within the community. This is why we occasionally find unique rock paintings. For instance, there is, as far as I know, only one painting of crabs – probably an idiosyncratic way of expressing the underwater experience of trance which is usually conveyed by depictions of fish (Fig. 16). We do not know if the painter attached special, esoteric meanings to crabs over and above the sensation of being underwater.

In considering the acquisition of spiritual insights, we must not emphasise the trance dance, central though it is, at the total expense of other ways of

obtaining glimpses of the spirit realm. For instance, Wilhelm Bleek and Lucy Lloyd recorded the ways in which |Xam shamans made rain and went on out-of-body travel in dreams. In a particularly striking twentieth-century instance, Beh, a Ju|'hoan woman, dreamed of galloping giraffes. When she awoke, she was able to discern in the rhythm of their pounding hoofs the metre of a new song. She was not herself a shaman, but when she sang the song to her husband, |Ai!ae, who was a shaman, he instantly recognised it as a new 'medicine song' imbued with potency. In a comparatively short time, the giraffe song had spread across the Kalahari and was being sung alongside older songs, such as those of eland and gemsbok. In some versions of this incident, it is |Ai!ae who received the song and taught it to Beh. Megan Biesele emphasises the centrality of altered states: 'Even the story of the revelation itself may be varied by further individuals as they recount it. What does not vary, however, is the sense that Beh or |Ai!ae was experiencing some sort of altered state of consciousness at the time of the inspiration for the song. These states, whether dreams, trances, or day-time confrontation with the spirits, are regarded as reliable channels for the transfer of new meaning from the other world into this one.'[53]

Finally, we must allow that people could have painted syntheses of experiences gathered and

remembered over a long period. The walls of the rock shelters presented timeless panoramas of imagery, not a series of disparate, temporal vignettes anchored in this world. Shamans in trance exist in a realm outside time.

Stage 2: The manufacture of paint

Very little was recorded about the ways in which San painters prepared their paint. There is, however, an important account that strongly suggests that the making of paint was far from a prosaic activity.

In the early 1930s, Marion Walsham How was able to converse with a 74-year-old southern Sotho man, Mapote. In his youth, he had learned to paint with San in their caves. He was the son of the Sotho chief Moorosi and had half-San stepbrothers, the sons of Moorosi's San wives. According to Mapote, the 'true' San painted at one end of the cave, while he and his half-San stepbrothers painted at the other end. A distinction between paintings at opposite ends of rock shelters has not been commonly observed, so we do not know how general this separation may have been or, indeed, how many southern Sotho people were taught how to paint. It may have been something that happened very seldom. Either way, Mapote's statement implies that the San whom he knew maintained a distinction between their own paintings and paintings

done by other people: painting, as they saw it, was an essentially San activity.

When How produced a lump of red pigment that a friend had given her some time before she met Mapote, he declared it to be authentic San pigment known as *qhang qhang*: it 'glistened and sparkled' in contrast to commercially available ochre, which was dull. *Qhang qhang* was dug out of the high basalt mountains, and many southern Sotho people also regarded it as a 'powerful medicine'.

The transformation of this highly prized pigment into paint was, according to Mapote, accompanied by ritual procedures. He said that a woman had to heat the *qhang qhang* out of doors at full moon until it was red hot. It was then ground between two stones until it was a fine powder. The production of red pigment was, therefore, at least in certain circumstances, a collective enterprise. As men and women collaborate in the trance dance, so too they collaborated in the making of paint. It should also be noted that San trance dances take place at night, frequently at full moon. Indeed, Arbousset and Daumas found that the San of what is present-day Lesotho danced at night 'by the light of the moon'.[54] In the event, How declined to part with any of her precious *qhang qhang*, and Mapote had to be content with commercial ochre obtained from the local store.

Then he asked for another highly significant ingredient: 'the blood of a freshly killed eland.'[55] *Qhang qhang* was the only pigment that the San mixed with eland blood; other pigments were mixed with other media. If the blood were not fresh, it would coagulate and not soak into the rock. As How observes, the need for fresh blood implies that painting took place after a successful eland hunt. Significantly, a large kill is one of the occasions that trigger a trance dance. Mapote then set about painting an eland because, as he put it, 'the Bushmen of that part of the country were of the eland'. Some of his paintings are on display in the Origins Centre, University of the Witwatersrand (Fig. 17).

The importance of eland blood as an ingredient in the manufacture of red paint was confirmed and enlarged upon in the early 1980s by an old woman of San descent who was living just south of the Drakensberg. She said that her father had been a shaman who painted, and she pointed out paintings that he had made many decades earlier. Her elder sister, who died a few years before she was interviewed, had been taught her father's shamanic (though not artistic) skills and had been known locally as a rain-maker.

According to this old woman, the whole sequence of events started with a ritualised eland hunt. She explained that a young girl accompanied a group of hunters who went out after an eland. This antelope

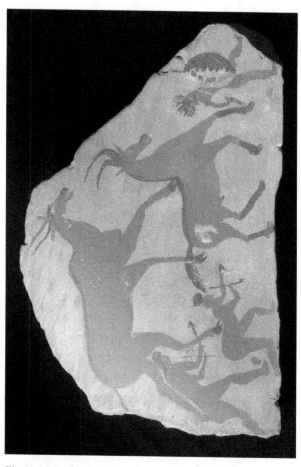

*Fig. 17. Mapote's painting made at the request of Marion
How in the 1930s.*

was considered God's special animal; still today, the Ju|'hoansi say that the eland has more potency than any other creature. As such, it needed a 'strong' person to overcome it. When the party came in sight of an eland, the girl 'hypnotised' it by pointing an arrow at it; on the arrow was 'medicine' that had been prepared by shamans. Although the age of the girl was not specified, it is worth noting that the |Xam spoke of a girl at puberty as having supernatural potency.

When the girl had exercised her power, the dazed eland was led back, again by supernatural means (though the movements of exhausted or wounded eland can in fact be easily controlled), to a place near the rock shelter where the paintings were to be made. The people then killed and dismembered the eland and prepared a mixture of its blood and fat. The woman explained that eland blood contained potency (she used the Xhosa word *amandla*, usually translated as 'power'). In Ju|'hoan boys' scarification rituals, this mixture of eland blood and fat is believed to imbue the recipient with eland potency. The woman went on to say that eland blood was also an ingredient in the preparation of paint, thus confirming Mapote's statement. She then said that when people dancing in the shelter needed more potency, they turned to face the images with eland blood. The paintings, especially those of eland, were storehouses of potency.

It appears that different kinds of paint were recognised, some with eland blood, some without, and, possibly, other kinds about which we know nothing. Clearly, for the San, rock paintings were far more than mere pictures and the processing of pigments more than just a material technique.

Stage 3: The making of rock paintings
The ways in which San painters applied paint to rock surfaces has been much debated. They achieved remarkably fine lines and delicate detail; the lines are often as fine as those made by a sharpened lead pencil on smooth paper. Marion How noted that Mapote made small brushes from feathers and tiny reeds, but it seems the very finest lines were made with something ever finer, perhaps a quill or sharp bone point.

The delicate workmanship and sureness of line suggest that it is unlikely that all shamans painted; it seems more likely that only some acquired this special skill. Nor does it seem likely that shamans painted while in deep trance; if not actually unconscious, they tremble violently. More probably, they painted while in a normal state of consciousness, recalling their vivid glimpses of the spirit world and making powerful images of those visions and of the animals that, like eland, were their principal sources of potency. Probably, the very act of painting (especially when they

knew that their paint contained potency) assisted in the recall, recreation and reification of otherwise transient glimpses of spiritual things. Like Wordsworth's observation on poetry, San rock art should probably be seen as powerful emotion recollected in tranquillity.

The status of paintings as something more than mere pictures is further seen in the way in which some of them enter or leave cracks, steps or other inequalities in the rock face. As I have pointed out, this feature is probably related to the belief that the spirit world was reached by an underground journey. As a 'veil' between realms, the rock itself provided a specific context for the images painted on it. In some ways the walls with their paintings were like stained glass windows in a church. If one finds an apparently secular object depicted in a window, one knows that it must relate to some sacred context. A small boat, for instance, in a stained glass window probably refers to St Peter the fisherman or to St Paul's journeys or, if it is a memorial window, to seafarers who lost their lives in a maritime tragedy. The boat is not simply a boat. It is there to evoke certain responses in viewers.

San images were thus 'things in themselves', not mere pictures. As 'fixed' visions, many had their own potency. Unfortunately, we do not know if the 'fixing' of visions was considered dangerous, as were spiritual journeys to the other world. Perhaps, like the dance in

which visions were acquired, this fixing of visions was also considered an appropriate occasion for the singing of 'medicine songs' to strengthen the shaman-painters in their work. Whatever the case, it seems unlikely that San painters were anything like the detached ascetics of the Western Romantic fiction.

Stage 4: The use of rock paintings

Once made, many San images seem to have continued to perform significant functions. The rock shelters were not simply 'galleries' where people could admire 'works of art'. As I have argued, many of the paintings were 'things in themselves', not just pictures of things that existed elsewhere. Some were reservoirs of potency. None of this implies that San people did not value the skill of their painters, just that the images were not primarily aesthetic achievements.

The old woman whose father had made paintings said that if a 'good' person placed his or her hand on a depiction of an eland, the potency locked up in the painting would flow into the person, thus giving him or her special powers. To demonstrate how this was done, she arranged my fingers so that my entire hand was on a depiction of an eland. As she did so, she cautioned that, if a 'bad' person did this, his or her hand would adhere to the rock and the person would eventually waste away and die.

The importance of touching and not merely looking at rock paintings is supported by evidence from the Western Cape where patches of paint have been rubbed smooth. It is not clear with what the patches were rubbed, but the smoothness of the rock, particularly in the centre of the patches, is easily discerned. Some of these paint patches are on the ceilings of rock shelters (as are some painted images); they could not have been palettes for mixing paint. Similarly, the making of positive handprints, which are common in some parts of the Western Cape and elsewhere, was probably associated with ritual touching of the rock rather than with the making of 'pictures' of hands.

There is thus evidence that some paintings were not made merely to be looked at. After they had been made, they continued to be involved in rituals in ways that we can glimpse but not fully understand. But the images were important visually as well. As 'fixed visions' the paintings probably impacted on the formation of people's mental images, some of which were themselves destined to be 'fixed' on the rock face. As time went by, certain rock shelters acquired more and more of these spiritual images. In some shelters paintings were done one on top of another even where there is plenty of vacant space, thus building up multiple layers of images, the oldest ones fading into a blurred red background. Layers of superimposed

images suggest that the art is three-dimensional: images extend back through the rock 'veil' into the spirit realm. Moreover, in some instances, paintings were carefully overpainted, apparently in an effort to renew them visually and spiritually. The most densely painted and 'renewed' shelters were probably regarded as places of exceptional personal or group power.

Amongst all those images, the eland stands out in numbers and in elaboration. What could Mapote have meant when he said that the San of that part of the country were 'of the eland'? In the English that How used to record his statement, it is difficult to be precise about what the preposition 'of' meant in this context. But, if we translate the phrase into a San language, we can see what Mapote meant: the 'of' at once makes sense. Again, we need to go back to actual San words and phrases. The |Xam informants spoke of shamans who had an association with various things such as springbok, rain, locusts and mantises. For instance, a certain woman was said to be *wai-ta !gi:xa*, that is, a shaman *of* (here, the possessive suffix is *–ta*) springbok (*wai*). This sort of relationship could be extended. The Ju|'hoansi call themselves 'owners of *n|om*', their word for potency. More specifically, John Marshall and Claire Ritchie found that the Ju|'hoansi say that they are, in general, 'owners of Giraffe Music'.[56] Thanks to Beh and |Ai!ae, the giraffe medicine song was very

134

popular at the time in the Kalahari. It is therefore likely that Mapote may also have been expressing an extension from shamans, the real controllers of eland potency, to all people. It was in that sense that the San, as a community, were 'of the eland'.

Living art

The making as well as continuing use of San rock art was a complex, multi-media practice. People could draw on the piled-up images when they needed potency. In addition, the images manifested what lay on the other side of the rock 'veil' and showed everyone what the shamans encountered when they passed through the 'veil'. The images lived on long after they had been painted.

The esteem in which San people must have held their paintings and the power that those images encapsulated underline the appropriateness of the image that today stands in the centre of South Africa's post-apartheid coat of arms. In ancient times, the art was there on the walls of rock shelters when people 'came together', as the motto proclaims. Ancient images can, in this way, exercise power in the present. In some sense, it could be said that the use to which the ancient San put their rock art continues today in the South African coat of arms. The art lives on. Daily, people still look at the central San image on coins, letterheads, government

buildings and so forth, and it can speak to them. In President Mbeki's phrase, in the accompanying |Xam language motto South Africans 'make a commitment to value life, to respect all languages and cultures and to oppose racism, sexism, chauvinism and genocide'.

Endnotes

1 <www.gov.za/speeches/>
2 Colenso 1994: 88 and
 Arbousset & Daumas 1846:
 252.
3 Impey 1926: 88.
4 Sparrman 1789, 2: 104.
5 Bleek 1874: 13.
6 Ibid.
7 Bleek 1875: 20.
8 Bleek 1924: unnumbered page.
9 Eric Rosenthal in Rosenthal
 and Goodwin 1953: 21.
10 Willcox 1956: 85.
11 Bleek 1874: 13.
12 Breuil 1955: 7.
13 Vinnicombe 1967: 284.
14 Maggs 1967: 102.
15 Werner 1908: 393.
16 Battiss 1958: 61.
17 Vinnicombe 1976: 353; Lewis-
 Williams 1972: 64.
18 Lewis-Williams 2002: 57, 58.
19 Lebzelter, quoted in Shapera
 1930: 198.
20 Stow & Bleek 1930: caption
 to pl. 2a; Bleek & Lloyd MS
 L.V.22.5754.
21 Bleek & Lloyd MS
 L.V.22.5760–5763;
 punctuation adjusted.

22 Arbousset & Daumas 1846:
 246–7.
23 Stow 1905: 111.
24 Biesele 1993: 71.
25 Ibid.: 70.
26 Katz et al. 1997: 108.
27 Ibid.: 81.
28 Keeney 2003: 83, 89.
29 Ibid.: 80.
30 Ibid.: 105.
31 Katz et al. 1997: 113.
32 Ibid.: 112.
33 Keeney 2003: 105.
34 Biesele 1993: 72.
35 Bleek & Lloyd MS L.II.6.669
 rev.
36 Katz et al. 2003: 24.
37 Keeney 2003: 85.
38 Biesele 1993: 70, 74.
39 Katz et al. 1997: 108.
40 Keeney 1999: 105.
41 Reichel-Dolmatoff 1979: 42.
42 Ibid.: 291.
43 Katz et al. 1977: 26.
44 Biesele 1980: 59.
45 B.XXVII.2540 rev.
46 Bleek 1933: 309.
47 Bleek 1938: 299.
48 Bleek 1932: 382.
49 Ibid.: 387.

50 Bleek 1933: 308.
51 Ibid.: 309, 310
52 Ibid.: 377.
53 Biesele 1993: 70.

54 Arbousset & Daumas 1846:
 246.
55 How 1962: 37.
56 Marshall & Ritchie 1984: 2.

Bibliography

Chapter 1
For a discussion of the coat of arms and motto, see
Barnard, A. 2004. Coat of arms and the body politic:
Khoisan imagery and South African national
identity. *Ethnos* 69: 5–22.

General references:
Lewis-Williams, J.D.1988. *The world of man and the
world of spirit: an interpretation of the Linton rock
paintings.* Second Margaret Shaw Lecture. Cape
Town: South African Museum.
Colenso, F. (*nom de plume*: Atherton Wylde) 1994.
*My chief and I or, six months in Natal after the
Langalibalele outbreak*, edited by M.J. Daymond.
Pietermaritzburg: University of Natal Press.
Impey, S.P. 1926. *Origin of the Bushmen and the rock
paintings of South Africa.* Cape Town: Juta.
Arbousset, T., & Daumas, F. 1846. *Narrative of an
exploratory tour to the north-east of the Colony of the*

Cape of Good Hope. Cape Town: A.S. Robertson & Saul Solomon.

Blundell, G. 2004. *Nqabayo's Nomansland: San rock art and the somatic past.* Uppsala: Uppsala University.

Challis, W. 2008. The impact of the horse on the Amatola 'Bushmen': new identity in the Maloti-Drakensberg mountains of southern Africa. Unpublished D.Phil. thesis, University of Oxford.

On the dating of rock art, see Mazel, A.D. 2009. Images in time: advances in the dating of Maloti-Drakensberg rock art since the 1970s. In Mitchell, P., and Smith, B.W. (eds.), *The eland's people: new perspectives in the rock art of three Maloti-Drakensberg Bushmen. Essays in memory of Patricia Vinnicombe,* pp. 81–85, 88–97. Pietermaritzburg: University of Natal Press.

Henshilwood, C.S. *et al.* 2002. Emergence of modern human behaviour: Middle Stone Age engravings from South Africa. *Science* 295: 1278–1280.

Wendt, W.E. 1976. '*Art mobilier*' from the Apollo 11 Cave, South West Africa: Africa's oldest dated works of art. *South African Archaeological Bulletin* 31: 5–11.

Maggs, T.M.O'C. 1995. Neglected rock art: the rock engravings of agriculturalist communities in South Africa. *South African Archaeological Bulletin* 50: 132–142.

Pearce, D.G. 2008. Later Stone Age burial practice in the Eastern Cape Province, South Africa. Ph.D. thesis, University of the Witwatersrand.

For more detailed accounts of San rock art, see: Lewis-Williams, J.D., & Pearce, D.G. 2004. *San spirituality: roots, expression, and social consequences.* Walnut Creek, CA: AltaMira Press; Cape Town: Double Storey.

Lewis-Williams, J.D., & Challis, S. 2011. *Deciphering ancient minds.* London: Thames & Hudson.

Lewis-Williams, J.D. 1981. *Believing and seeing: symbolic meanings in southern san rock paintings.* London: Academic Press.

Chapter 2

Sparrman, A. 1789. *A voyage to the Cape of Good Hope.* London: Lackington.

Bleek, W.H.I. 1874. Remarks on Orpen's 'A glimpse into the mythology of the Maluti Bushmen'. *Cape Monthly Magazine* (n.s.) 9: 10–13.

Bleek, D.F. 1924. *The Mantis and his friends.* Cape Town: Maskew Miller.

Bleek, W.H.I., & Lloyd, L.C. 1911. *Specimens of Bushman folklore.* London: George Allen.

Hollmann, J.C. (ed.) 2004. *Customs and beliefs of the ǀXam Bushmen.* Johannesburg: Witwatersrand University Press.

Orpen, J.M. 1874. A glimpse into the mythology of the Maluti Bushmen. *Cape Monthly Magazine* (n.s.) 9 (49): 1–13.

Burkitt, M.C. 1928. *South Africa's past in stone and paint.* Cambridge: Cambridge University Press.

Breuil, H. 1955. *The White Lady of the Brandberg.* London: Trianon Press.

Vinnicombe, P. 1967. Rock painting analysis. *South African Archaeological Bulletin* 22: 129–141.

Vinnicombe, P. 1967. The recording of rock paintings: an interim report. *South African Journal of Science* 63: 282–284.

Maggs, T.M.O'C. 1967. A quantitative analysis of the rock art from a sample area in the Western Cape. *South African Journal of Science* 63: 100–104.

Vinnicombe, P. 1976. *People of the eland: rock paintings of the Drakensberg Bushmen as a reflection of their life and thought.* Pietermaritzburg: University of Natal Press.

Lewis-Williams, J.D. 1972. The syntax and function of the Giant's Castle rock paintings. *South African Archaeological Bulletin* 27: 49–65.

Lewis-Williams, J.D. 1982. The economic and social context of southern San rock art. *Current Anthropology* 23: 429–449.

Lewis-Williams, J.D. 1990. Documentation, analysis and interpretation: problems in rock art research.

South African Archaeological Bulletin 45: 126–136.

Campbell, C. 1986. Images of war: A problem in San rock art research. *World Archaeology* 18: 255–268

Challis, S. 2009. Taking the reins: The introduction of the horse in the nineteenth-century Maloti-Drakensberg and the protective medicine of baboons. In Mitchell, P. and Smith, B.W. (eds.), *The Eland's People: Essays in Memory of Patricia Vinnicombe,* pp. 104–107. Johannesburg: Witwatersrand University Press

Amongst the well-illustrated books are:

Willcox. A.R. 1956. *Rock paintings of the Drakensberg.* London: Parrish. Lee, D.N., & Woodhouse, H.C. 1970. *Art on the rocks of southern Africa.* Johannesburg: Purnell.

Battiss, W. 1948. *The artists of the rocks.* Pretoria: Red Fawn Press. Pager, H. 1971. *Ndedema.* Graz: Akademische Druck.

Townley Johnson, R. 1979. *Major rock paintings of southern Africa.* Cape Town: David Philip.

Rosenthal, E., & Goodwin, A.J.H. 1953. *Cave artists of South Africa.* Cape Town: Balkema.

Chapter 3

Bank, A. 2006. *Bushmen in a Victorian world: the remarkable story of the Bleek-Lloyd Collection of*

Bushman folklore. Cape Town: Double Storey, Juta.

Wessels, M. 2010. *Bushman letters: interpreting |Xam narrative*. Johannesburg: Witwatersrand University Press.

Lewis-Williams, J.D. 2002. *Stories that float from afar: ancestral folklore of the San of southern Africa*. Cape Town: David Philip.

Stow, G.W., & Bleek, D.F. 1930. *Rock paintings in South Africa: from parts of the Eastern Province and Orange Free State*. London: Methuen.

Skotnes, P. 2007. *Claim to the country: the archive of Wilhelm Bleek and Lucy Lloyd*. Cape Town: Jacana. Athens: Ohio University Press.

Bleek, D.F. 1956. *A Bushman dictionary*. American Oriental Series, Vol. 41. New Haven, CT: American Oriental Society.

Marshall, L. 1976. *The !Kung of Naye Naye*. Cambridge, Mass.: Harvard University Press.

Marshall, L. 1999. *Nyae Nyae !Kung beliefs and rites*. Cambridge, Mass.: Harvard University Press.

Lee, R.B. 1979. *The !Kung San: men, women, and work in a foraging society*. Cambridge: Cambridge University Press.

Biesele, M. 1993. *Women like meat: the folklore and foraging ideology of the Kalahari Ju|'hoan*. Johannesburg: Witwatersrand University Press.

Barnard, A. 2007. *Anthropology and the Bushman*.

Oxford: Berg.

Guenther, M. 1989. *Bushman folktales: oral traditions of the Nharo of Botswana and the ǀXam of the Cape.* Stuttgart: Franz Steiner Verlag.

Guenther, M. 1999. *Tricksters and trancers: Bushman religion and society.* Bloomington: Indiana University Press.

Chapter 4

Schapera, I. 1930. *The Khoisan peoples of South Africa.* London: Routledge & Kegan Paul.

Stow, G. W. 1905. *The native races of South Africa: a history of the intrusion of the Hottentots and Bantu into the hunting grounds of the Bushmen, the aborigines of the country.* London: Swan Sonnenschein.

Lewis-Williams, J.D., & Challis, S. 2011. *Deciphering ancient minds: the mystery of San Bushman rock art.* London: Thames & Hudson.

Blundell, G. 2004. *Nqabayo's Nomansland: San rock art and the somatic past.* Uppsala: Uppsala University Press.

Lewis-Williams, J.D. 1981. *Believing and seeing: symbolic meanings in southern San rock paintings.* London: Academic Press.

Lewis-Williams, J.D. 1992. Ethnographic evidence relating to 'trance' and 'shamans' among

northern and southern Bushmen. *South African Archaeological Bulletin* 47: 56–60.

Lewis-Williams, J.D., & Biesele, M. 1978. Eland hunting rituals among northern and southern San groups: striking similarities. *South African Archaeological Bulletin* 48: 117–134.

Kriel, T.J. 1958. *The new English–Sesotho dictionary.* Pretoria: APB.

For accounts of San shamanism and 'threads of light', see: Biesele, M. 1993. *Women like meat: the folklore and foraging ideology of the Kalahari Ju\|'hoan.* Johannesburg: Witwatersrand University Press.

Keeney, B. 2003. *Ropes to God: experiencing the Bushman spiritual universe.* Philadelphia: Ringing Rocks Press.

Keeney, B. 1999. *Kalahari Bushmen healers.* Philadelphia: Ringing Rocks Press.

Katz, R. 1982. *Boiling energy: community healing among the Kalahari San.* Cambridge, Mass.: Harvard University Press.

Katz, R., Biesele, M., & St. Denis, V. 1997. *Healing makes our hearts happy: spirituality and cultural transformation among the Kalahari Ju\|'hoansi.* Rochester: Inner Traditions.

Lewis-Williams, J.D., Blundell, G., Challis, W., and Hampson, J. 2000. Threads of light: re-examining a motif in southern African rock art. *South African*

Archaeological Bulletin 55: 123–136.

Chapter 5

Siegel, R.K. 1977. Hallucinations. *Scientific American* 237: 132–140.

Siegel, R.K., & Jarvik, M.E. 1975. Drug-induced hallucinations in animals and man. In Siegel, R.K., & West, L.J. (eds.), *Hallucinations: behaviour, experience, and theory*, pp. 81–161. New York: Wiley.

Reichel-Dolmatoff, G. 1978. *Beyond the Milky Way: hallucinatory imagery of the Tukano Indians*. Los Angeles: UCLA Latin America Center.

For summaries of the application of neuropsychological research to rock art, see: Lewis-Williams, J.D. 2002. *The mind in the cave: consciousness and the origins of art*. London and New York: Thames & Hudson.

Lewis-Williams, J.D., & Pearce, D.G. 2005. *Inside the Neolithic mind: consciousness, cosmos and the realm of the gods*. London: Thames & Hudson.

On snakes, see Biesele, M. 1980. Old K'xau. In Halifax, J. (ed.), *Shamanic voices: a survey of visionary narratives*, pp. 54–62. Harmondsworth: Penguin.

Chapter 6

Orpen, J.M. 1874. A glimpse into the mythology of the Maluti Bushmen. *Cape Monthly Magazine* (n.s.) 9 (49): 1–13.

Lewis-Williams, J.D., & Pearce, D.G. 2004. Southern African rock paintings as social intervention: a study of rain-control images. *African Archaeological Review* 21: 199–228.

Vinnicombe, P. 1976. *People of the eland: rock paintings of the Drakensberg Bushmen as a reflection of their life and thought.* Pietermaritzburg: University of Natal Press.

Lewis-Williams, J.D. 1981. *Believing and seeing: symbolic meanings in southern San rock paintings.* London: Academic Press.

Bleek, D.F. 1933. Customs and beliefs of the |Xam Bushmen: Part V: The rain. Part VI: Rain-making. *Bantu Studies* 7: 297–312, 375–392.

Dowson, T.A. 1998. Rain in Bushman belief, politics and history: the rock art of rain-making in the south-eastern mountains, southern Africa. In Chippindale, C., & Taçon, P.S.T. (eds.), *The archaeology of rock art,* pp. 73–89. Cambridge: Cambridge University Press.

Chapter 7

Lewis-Williams, J.D. 1995. Modelling the production and consumption of rock art. *South African Archaeological Bulletin* 50: 143–154

Lewis-Williams, J.D. 1987. A dream of eland: an unexplored component of San shamanism and

rock art. *World Archaeology* 19: 165–177.

Dowson, T.A. 2007. Debating shamanism in southern African rock art: time to move on. *South African Archaeological Bulletin* 62: 49–61.

How, M.W. 1962. *The mountain Bushmen of Basutoland*. Pretoria: Van Schaik.

Lewis-Williams, J.D., & Challis, S. 2011. *Deciphering ancient minds*. London: Thames & Hudson.

Yates, R., & Manhire, A. 1991. Shamanism and rock paintings: aspects of the use of rock art in the south-western Cape, South Africa. *South African Archaeological Bulletin* 46: 3–11.

Townley Bassett, S. 2001. *Rock paintings of South Africa: revealing a legacy*. Cape Town: David Philip.

Jolly, P. 1986. A first-generation descendant of the Transkei San. *South African Archaeological Bulletin* 41: 6–9.

Lewis-Williams, J.D. 1986. The last testament of the southern San. *South African Archaeological Bulletin* 41: 10–11.

Lewis-Williams, J.D. 1988. 'People of the eland': an archaeo-linguistic crux. In Ingold, T., Riches, D., & Woodburn, J. (eds.), *Hunter gatherers: property, power and ideology*, pp. 203–211. Oxford: Berg.

Marshall, J., & Ritchie, C. 1984. *Where are the Juǀwasi of Nyae Nyae?* Cape Town: Centre for African Studies, University of Cape Town.

Acknowledgements

The copy of the Linton panel (Fig. 2) was made by Thomas Dowson, Paul den Hoed and Zac Kingdon in 1986 and appears by kind permission of the director of the Iziko South African Museum. The photograph of the Blombos engraved ochre (Fig. 5) appears courtesy of Chris Henshilwood; that of Wilhelm Bleek (Fig. 6) courtesy of Jagger Library, University of Cape Town. The photograph of a San man (Fig. 8) comes from the Marshall family collection by permission of the late Dr Lorna Marshall. The photograph of the San shaman in trance (Fig. 9) appears by permission of Jürgen Schadeberg (ww.jurgen.schadeberg.com; *The San of the Kalahari*, 2002, Pretoria: Protea Book House). The Van der Byl family permitted publication of the photograph of Mapote's paintings, now in the Origins Centre, University of the Witwatersrand. Other illustrations of San rock art come from the collections of the Rock Art Research Institute, University of the

Witwatersrand. Fig. 15 was made by Harald Pager. Quotations from the Bleek & Lloyd Collection are by permission of Jagger Library, University of Cape Town. David Pearce kindly collated and scanned the illustrations.

Index

Printed in the USA
CPSIA information can be obtained
at www.ICGtesting.com
LVHW010819270923
758971LV00019B/337

9 780821 420454